Dutched Up!

Rocking the Clogs
Expat Style

By Expat Women Bloggers

Table of Contents

Introduction

As we all know, the Netherlands is a very unique country, with its paracetamol-loving doctors, a deep appreciation for *gezelligheid*, and the ever-present *bitterballen*.

In March 2013, we came up with the idea for this book. We each knew several other expat bloggers and we wanted to show how different our experiences here are. We set off on a search to find more women with more tales of living in the Netherlands and found talented ladies from all over the world who now call this little country home.

There is a common thread that connects us. Some of us are funny. Others have a wealth of professional information that they're very kind to share. Yet other stories are sad, shocking or surprising. We have experiences and stories to tell, and above all, we are all unique.

There is one thing we can guarantee about this book. At least one story in it will resonate with you. In all likelihood, there are a lot of stories that will sound familiar and have you nodding your head in agreement or shaking it in shared frustration. We want to not only shed light on the difficult moments, but also appreciate the many moments of beauty, learning and growing.

We set out to tell the story of life in the Netherlands as expat women. What we found is a story as multifaceted as the women who call this country home. We hope that you enjoy reading it as much as we did writing it.

Olga Mecking, The European Mama
and
Lynn Morrison, Nomad Mom Diary

Foreword

Having lived in the Netherlands for over 30 years, with a Dutch husband and university-going children, I tend to consider myself part of the furniture. So it was with perhaps a little trepidation that I turned to *Dutched Up – Rocking the Clogs, Expat Style*. Had I not been there, done that? Would I be confronted with clichés which have long ceased to shock, and preconceptions which had long since blown away?

Not at all.

After the first contribution, I found myself jotting down notes: small baby (yep, as a short English woman I've been through that one); small bike (yep I still struggle to find a bike which allows me to put my feet on the ground); having children who speak better Dutch than you – oh absolutely, even after 30 plus years.

Yes, there are the bus drivers who accuse you of being rude, discount spinach you don't want, the visitors from hell who won't go home, the awful silence when your six-year-old says 'shit' in front of his English grandparents, the horribleness of weak fruit tea, the unbelievable fabulousness of *kraamzorg*, the fact that you will never truly understand your Dutch husband – it all seems so familiar and so true. I had forgotten quite how.

If you are a new arrival, this book will let you know you are not alone. If you've been here for some time, you will find yourself nodding in agreement and if you've left, you will find yourself nostalgic for a rusty bike and glass of hot water that once looked at a teabag.

I came to the Netherlands first in 1981 as an *au pair* for an expat family and I'm still here. Be aware, this country has a way of growing on you. Thank you Expat Women Bloggers for making me smile, occasionally making me wince and making me remember.

Robin Pascoe
Editor
DutchNews.nl

I

Tales of Culture Shock

Openness
Tamkara Adun
Naija Expat in Holland

I know the contents of my neighbour's kitchen.

I can describe the colourful flowers that line her kitchen windowsill. I really like the transparent glass jars where she keeps pasta and cereal and just the other day, I got transparent glass jars of my own.

Now before you judge me and label me a voyeur, you should know that I do not actively seek out the fine details of my neighbour's abode. The eyes will roam where they will and mine cannot help but roam to a kitchen so beautifully put together especially when the windows are forever open and never to be shut.

The Dutch are known to be a direct and open bunch and this is aptly reflected in their houses. Most of which have large windows through which you can see virtually everything that lies within.

It's what I like to call a "you see me and I see you" kind of arrangement.

No place for clattered kitchens or disarranged living rooms with toys strewn about from pillar to post. What you see are impeccably arranged living rooms, spotless kitchens, massive houseplants. And of course, open windows for you to admire the view. After all, is it really worth all that trouble if no one is allowed to admire?

The openness of Dutch buildings gives them a certain *je ne sais quoi*. It adds a beauty, a familiarity and warmth that make them unique. Coming from West Africa, where high walls and metal-gated fortresses are the norm, I found the openness of Dutch buildings to be a tad unsettling. I felt quite uncomfortable walking past my neighbour's house and seeing right into her dining area as they sat down to a meal.

In the beginning, I would try to avert my eyes and increase my pace and it took a while to adjust. Now, I do not shy away from the open windows. Instead, I let my gaze roam far and wide. I see the man at the window dusting his furniture. I see the lady sitting at a table, hard at work on her laptop. I see the great big flowerpots and stylish furniture. I see a great deal, and it's no longer uncomfortable. As I take it all in, I

make mental commentaries in my head of things I would like to copy or things I would like to change if I had a say in the matter.

Yes, my neighbour's kitchen always looks impeccable; we have already established that as a fact. What I neglected to mention was that it makes my kitchen look drab and quite frankly, extremely disorganized. This, in turn, makes me very thankful that my kitchen is at the back of my house and out of sight of passers-by.

Had the tables been turned, I shudder to think what I would have done with my never-ending supply of dirty dishes and crockery.

This Dutch culture of openness has also been linked to Dutch directness in other areas such as communication and business. The Dutch have this amazing ability to look you in the eye and tell you the bitter truth to your face without flinching or batting an eyelid. It matters not whether you have requested that dose of bitter truth or not; chances are that you will get it anyway.

I experienced this for myself in a group discussion where a lady begun to tell a story that, unbeknownst to her, she had told the day before. She repeated in great detail exactly the same sequence of events as she had already done earlier.

Since I had heard the story less than 24 hours before, I knew the drill, I knew the punch line and I was prepared to laugh hard and laugh long when it came around. As she approached the punch line, I slowly began to build up enough momentum to express my mirth.

Then the unthinkable happened. My Dutch friend interjected and said with supreme conviction: "But you have already told us the exact same story yesterday!"

I gasped and blinked simultaneously. I thought to myself, surely we could have endured 30 seconds more of the tale. It would not have killed anyone!

But then again, that's the Dutch directness for you! Deal with it or be consumed.

Just as people who live in glass houses should not throw stones, people who live in cluttered houses should definitely not embrace the Dutch "see me, I see you" open window policy.

If you have something to hide, such as an overflowing kitchen sink or a

topsy-turvy living room, you would do well to keep your curtains dark and your windows shut.

Tamkara Adun moved to the Netherlands from Nigeria in 2013 with her husband and two children. She manages a blog at Naija Expat in Holland, where she shares her thoughts on expat life in The Netherlands as she juggles work, study and family in her new location. She is currently studying for her MBA at the Rotterdam School of Management, Erasmus University and is a contributing writer at Women of HR. You can connect with her on twitter @tamkara. Tamkara is an ardent lover of family trips, social media and great food. A few hours of blissful solitude as she digs into a great book is one of her favourite things. She looks forward to a day where trailing spouses no longer feel the need to trail but would rather blaze a trail.

Small talk: Tall tales about being short in the Netherlands
Deepa Paul
Currystrumpet

It was inevitable, and I knew it.

As a choir nerd of nearly 15 years, I knew it was only a matter of time until "Short People"—a novelty ditty popularized by the King's Singers and a long-time favourite on the amateur a capella circuit—found me. "Short People" had lain in wait my entire choral career until I, a 1.57-meter tall woman, had moved to the Netherlands, home to the tallest humans on earth. Then it pounced.

As I sang about having little baby fingers and nobody to love, the soprano beside me—all 1.8 meters of her—bent and coughed discreetly, squinting at the sheet music we were sharing.

"Sorry!" I chirped. "Can you see? Is this better?" Being Southeast Asian, it's a given that I'm short, but did I mention I'm also exceedingly polite and eager to please? I lifted the sheaf of papers higher, bringing them to a comfortable reading height for my colleague—which was closer to her chest and somewhere around my nose.

Oh, the indignity.

Of all the quirks of life in the Netherlands, being a short person in a society of exceptionally tall people quite took me by surprise. It still does, in ways both big and (ahem) small. Let's start by looking at the numbers.

I come from the Philippines, which produces the second shortest people in Southeast Asia, a region where height is in short supply to begin with. The average Filipino is 1.62 meters in height, while the average Filipina stands 1.5 meters.

Compare this to the average Dutch male, who is 1.83 meters tall, and the average Dutch woman, who just brushes the 1.7-meter mark. This means that the Dutch tower over my kind by a whopping 20 to 21 centimetres, or about one average human head.

I don't know about you, but to me that's a pretty big gap, and one that

I eye with longing. Maybe it's a Filipino thing. After all, I come from a nation of short people whose national obsession is basketball. We so very much want to be tall.

What's it like to finally live among the people whose genetic gifts we envy?

Apparently, it's not easy—even for them. A look at the website of the Klub Lange Mensen, an actual Dutch organization for tall people (which has 609 presumably tall Facebook followers, although I'm positive there should be more like 16 million) reveals some of the struggles that the tall Dutch face.

The website ponders such questions as "What does alcohol do to you when you're over six feet?" (The short answer: probably something less entertaining than if you're just a few squeaks over five feet), laments the invention of airplane seats that whittle away on already precious legroom, and calls for affection on February 11, which is officially Hug A Tall Person Day.

Now, bend down real low and put your ear to my lips, because I'm going to tell you a secret. Like #firstworldproblems, #shortpeopleproblems are funny, but they exist.

I'm not going to talk about how research is stacked high against us short people. Though the Klub Lange Mensen website gleefully shares such pro-tall findings such as those of researchers at the University of Edinburgh (who proved that short people often have lower IQs than taller people), I'm not going to rant about how science proves not only are we short, we're also pretty much doomed to be dumb and poor.

Nope! I'm going to talk about the fun stuff—like toilets.

The first time I used a public restroom in the Netherlands is seared in my memory. On my second day in Amsterdam after having relocated from Singapore, my husband and I had dinner at a small, cosy café in the Jordaan. When I went into the ladies' for a lipstick check, lo and behold, the mirror was hung so high above me that I could only see the top of my head.

What was a (short) girl to do? I patted my scalp to ensure its neatness, jumped up and down a few times to see if my fringe needed combing, and plopped on the toilet. I say "plopped" and not "plopped down",

because I didn't even need to bend my knees to rest my butt on the seat. "Well, this is no way to do business!" I thought. I wiggled and squirmed until my bottom was where it needed to be, an act of acrobatics that took my feet clear off the floor. I felt all of five years old, my toes angling above the tiles while I tinkled.

I've never asked my husband if he's ever actually had to tiptoe at a Dutch urinal. Maybe I should, but do I really want to know? I get to feel like a five year-old all the time, since this happens multiple times a day in my very own house. Yes, I live in an apartment where my feet don't touch the floor when I sit down to pee.

Short people may be better suited for the low ceilings and head-bonking, oddly jutting beams of 16th century Dutch canal houses. But that's only if our little baby legs make it up the vertiginous Dutch Stairs of Death™ first. While the Dutch spring confidently up their steep, narrow stairs with the light-footedness of young gazelles, I trail behind huffing and puffing, hiking my knee to my chest and seeing my life flash before me with each step.

Pregnant, hormonal and severely nesting during our house hunt, I fell so head over heels in love with our apartment that I barely noticed how the previous owners had raised their entire kitchen about 20 centimetres off the floor. It was only after we moved in when I realized that the oven door opened to roughly the level of my chin, and that I couldn't reach over the kitchen counter to the power outlet in the corner without tiptoeing. After a daily regimen of frequent tiptoeing to plug in my own appliances, I now boast calves that would make a ballerina weep. It almost makes up for feeling like a hobbit in my own home.

Speaking of being pregnant, the way a 1.57-meter Filipina and a 1.7-meter Dutch woman carry their baby bumps couldn't be more different.

The closer I came to 40 weeks, the more dangerously my baby belly threatened to overwhelm my frame. While I heaved my unborn child around as if she was a bowling ball, Dutch supermoms would whizz past me on their bikes and *bakfietsen*, their tall frames sporting their full-term bellies—plus two kids, the groceries and a dog—with ease and grace.

Despite my heaving and panting, the echographer pronounced my daughter a small baby at our 28-week ultrasound. "I am not surprised. The parents are also small," he said with typical Dutch bluntness. The description stuck. After she was born, I heard "*Kleine babytje, kleine babytje*" so often in trams and on the street that it nearly drove me to violence.

In my dreams, I snarled back, No she's not! She's not a small baby because she's not Dutch! She's a perfectly normal Filipino baby! Of course, I never did. I instead retaliated with nose-in-the-air statements like, "I prefer French brands for my daughter, but only because the sizes run so small and skinny."

I wonder if raising my daughter in the Netherlands will somehow give her the Dutch height. Is it something in the air? Is it all the dairy? Does my Filipina baby have a future as a model? Or is she doomed to, like her mama, forever hack six centimetres off every skirt and pair of trousers that she buys? Only time will tell.

My husband, a lifelong martial arts enthusiast who knows karate and judo, is convinced that the irresistible combination of being short and different will make our daughter a bully magnet. At 1.7 meters, my beefy husband is considered a big guy back home. His feeling of invincibility disappeared when he tried to stop a fight between two Dutch women in the tram. As soon as he stepped between the two snarling, slapping, hair-pulling females, he realised, to his embarrassment and horror that they towered over him.

It probably wasn't a coincidence that shortly after, he enrolled in krav maga, a streetwise fighting style and system of self-defence developed for the Israeli military police. He can't wait to put our daughter in kiddie krav maga as soon as she turns four.

As a person of short stature, I too have taken my share of hits from Dutch women, mostly while trying to navigate a packed tram. Though those elbows in the neck and purses in the face are unintended, it doesn't make them hurt any less. It does, however, give new meaning to the words "That's a killer handbag!"

Seeking salvation from getting clobbered on public transport on a regular basis, I embraced the Dutch cycling culture. I bought an

adorable baby-blue beach cruiser in Singapore and brought it with me when we moved. I thought I would look cute and chic, cycling along the canals of Amsterdam in retro style. I was cute, all right. But not in the cool, stylish way that I had hoped, but in the odd, small way reserved for Chihuahuas and *Toddlers and Tiaras*.

I get funny looks when I'm on my bike. They're the same looks I got when, on a weekend trip to Texel, I couldn't find a rental bike my size and had to settle for a little girl's bike emblazoned with pink daisies and the words "GIRL POWER!" in flaming pink.

I've seen 10 year-old girls on bikes bigger than mine. In fact, my bike is so small; it has proven to be the most theft-proof bike in Amsterdam, a city where a bike is purportedly stolen every nine seconds. I've left my bike unlocked in various locations, sometimes for weeks, only to find it standing in the same spot, looking slightly sheepish but otherwise unmolested.

Dutch thieves are probably too embarrassed by my bike to steal it, or think no self-respecting Dutch person would be able to ride it, thus eroding its possible resale value. Perhaps they think it's a baby bike and simply won't stoop that low (literally), which makes Dutch bike thieves surprisingly more decent than I thought.

Does size matter? I suspect it does. The fact that the Argentinean import Queen Maxima wears a size 42 shoe may have had some bearing on her warm welcome by Dutch society. Before she disappeared into that famous convent and emerged speaking flawless Dutch, I suspect the nation took one look at her feet and decided "She's one of us!"

My feet are size 37 and narrow, so I guess I just have to try harder.

Fortunately, life in the Netherlands gives me many reasons to keep at the work of integration, and in that *rekening*, meters and centimetres don't count. So getting my butt onto a bar stool at a *bruin café* will always feel like mounting an Everest expedition. So having a cocktail will inevitably mean resting my glass on a table that comes up to my chest (I'm looking at you, House of Bols). So I can never show up late to a standing room concert. So what?

When it comes to fitting in, being a small person in the land of giants means I will always stick out. When even Dutch furniture has longer legs than I do, daily life requires that much more effort from me just to

seem normal and fit in. It's a tall order, but isn't that what embracing life in a new land is all about?

Living in the Netherlands has taught me, size does matter. The long and short of it is that it's not the only thing that does.

Deepa Paul is a storyteller, mother and wanderer from Manila, living in Amsterdam, by way of Singapore. She juggles her career as a freelance writer and producer with life as a work-at-home mom to her one year-old daughter Tala and a wife, partner, and obsessive travel planner to her husband Marlon. She loves life and writing, discovery and details. She loves words: the challenge of searching for the right ones, and the satisfaction of finding them. She fills her blog, Currystrumpet with vivid stories of family, home, travel, creativity and life in Amsterdam.

The Rules
Nerissa Muijs
Adventures in Integration

Since moving to the Netherlands in 2008, I have become acquainted with some very strict rules regarding eating and entertaining.

Australians are very casual and laid back about this, so I really did struggle with some of the adjustments I had to make.

My first introduction to The Rules was in the supermarket, not long after I first arrived. My husband and I were searching for something to eat for dinner, and we came across the rendang paste in the exotic foods aisle. I pointed out that rendang was great with chicken, but my husband was having none of it. "No," he insisted. "See, this is for meat. It says so on the packaging. *Vlees rendang*. Not *kip rendang*." My buts and whys fell on deaf ears and the only answer given was "it's The Rules".

The Rules began to consume me in the first year or so. Before the first evening party we hosted for family, I was becoming increasingly stressed about what to serve when, as per The Rules. My husband insisted that it didn't matter and that I should just do what I wanted. So I did just that.

As I would in Australia, savouries came out first, the cheese and crackers, along with the wine. I set it all lovingly on the table and admired my handiwork with pleasure, only to turn around and see it all being carted back to the kitchen so we could drink coffee and eat cake first. Seriously, I was in desperate need of that wine! I may well have had a sneaky slug while hiding in the kitchen.

I've since discovered that when we have guests (or a dreaded Dutch Circle Party), serving cake and coffee first is paramount. We don't wait for a specific moment to serve cake. It's served on a first come, first served basis. If you're late to a party and everybody has moved on to their glass of wine and nuts, you'll still be served cake (and offered coffee). It's The Rules.

When making arrangements to have guests over for a drink, an appointment is absolutely essential. Arriving unannounced will not be

received well, and you'll be lucky to be let through the front door. It is, however, completely unnecessary to arrange a precise time. *Koffietijd* (coffee time), or *thee* (tea) is enough. *Koffietijd* is at 10:00 and 20:00, whereas *thee* is at 14:00, or 16:00 if you are planning on having dinner together. As a colleague of mine pointed out, he will always make it clear that a guest is not invited for dinner.

Coffee is often served black and always strong. Instead of adding milk, you may be offered liquid creamer (*koffiemelk*) or powdered creamer (*koffiemelkpoeder*). Tea is always black, and more often, fruity and very weak. Being an obsessive English breakfast drinker, drinking tea is a minefield for me. I have had a friend who knows how I drink my tea serve me fruity tea filled with milk.

Then, of course, there is the infamous one cookie stereotype. In all honesty, this is not something that I have really experienced. What I do notice however, is the token extra cookie that nobody touches. It is like an unspoken rule; the cookie is offered, but nobody is allowed to eat it.

If you are lucky enough to be invited to stay for dinner, make sure you are on time. It is nothing to have guests arrive forty-five minutes early; meanwhile I'm still in a towel and the floor hasn't been mopped since 2011. Dinner is promptly at 18:00. Whenever we visit my husband's grandparents and arrive by 18:15, we are already late.

We walk in and sit straight down to eat. No socialising first, no pre-drink, just hurry up, it's getting cold. Once we have eaten soup (there's always soup) and our *boerenkool* (kale, mashed potato and smoked sausage, slathered in gravy), we are served dessert and then offered coffee. Promptly after that, it's time to leave.

Aside from the social aspect of eating and drinking in the Netherlands, there are a few rules that one must bear in mind as a resident in this lovely little country. A sandwich, or *boterham*, is one slice of bread with cheese or some type of pressed meat or even *hageslag*, which is a type of flavoured sprinkle. It's also commonplace to eat your sandwich (one slice of bread) with a knife and fork. To complement your sandwich, you are expected to drink milk or buttermilk with lunch. As per The Rules, your milk should also be served in a mug or cup, not a glass.

Frieten (French fries) are always served with mayonnaise—not tomato

sauce, not gravy (oh, how I miss chips and gravy) or vinegar, but mayonnaise. You will always be offered mayonnaise or *frietsaus* when ordering hot chips, or a meal served with chips. Failing that, you will just receive it automatically.

On your birthday, it is customary to bring cake of some kind to the office to share. "Hey, it's my birthday! I brought my own cake in case you all forgot about it." At school or daycare, you are expected to bring a treat for all of your classmates on your birthday. What happened to receiving gifts? Why do we have to give them on our own birthdays?

Birthdays are a very big deal in the Netherlands, no matter how old you are. You are expected to celebrate in one way or another, usually with a dreaded Circle Party, or at least have coffee and cake with your extended family. You're also expected to wait on your guests hand and foot. God forbid someone helps themselves to the coffee pot or gets up to help.

It's much the same deal when you have a baby. Endless streams of visitors who expect to be waited on while you nurse a newborn. In this case you're also expected to serve *beschuit met muisjes*, which is a type of rusk biscuit smeared with butter and aniseed flavoured sprinkles. They're very delicious, but extremely crumbly so tend to drop all over the floor to be cleaned up after the guests leave. Just one extra task for a new parent who has nothing better to do, but it's The Rules so must be done.

Lastly, one learned in *inburgering* (integration classes): You may not slaughter sheep in your bathtub. It's The Rules.

Nerissa Muijs had big plans. She was going to see a few castles in England before going home to continue her dream career as a tour guide along the west coast of Australia before retiring with too many cats. Then something happened. A boy derailed all of the carefully laid plans and pulled her to the Netherlands before popping the question and getting her up the duff in rather quick succession. She is obsessed with crochet and can't stop talking about it at Miss Neriss. Nerissa spent years as blogger writing about integrating in the Netherlands and the dreaded Inburgering exams at Adventures in Integration. Nerissa is also a mum of

a precocious yet adorable little girl and desperately wants a dog. But her husband won't get one.

Bus drivers have feelings too

Donna Stovall Bardsley

Bardsleyland

We were running a bit late.

As we tumbled down our front steps in various states of undress, the #65 bus roared past us towards the bus stop. The stop where we were supposed to be waiting, calmly and serenely.

Instead I was yelling "Go, go, go, go, run, run, fast!" as we sprinted after the bus. I scooped up my pyjama-clad three-year-old with one arm, while clutching a mess of jackets, clothes, shoes, socks and umbrellas in the other. My husband grabbed the hands of our older two children, dragging them across the traffic lanes in the wake of the bus.

Missing the bus meant waiting thirty minutes for the next one and while we could have cycled to our appointment in that amount of time, it would have meant getting drenched in the autumn rain.

"Public transportation gets you everywhere in Europe, and it's so efficient." We'd been told so many times, we didn't ever question it. But as we were learning, that didn't mean it ran on the schedule you wanted, nor that it would be easy to get five people ready to go and out the door by 9:23 on a Sunday morning, with not a minute's leeway.

It had been just two months since we'd sold both of our cars, rented out our house in the Seattle suburbs and moved our three kids into an apartment in Amsterdam, where we relied entirely on bicycles and public transportation to get around. Clearly, we had not quite adjusted to a car-free lifestyle.

"We can't keep doing this," my husband said.

"Not now," I spit back.

The bus had stopped up ahead and the doors were opening. We ran the length of the beast, and threw ourselves into it.

"I can't believe we made it." I was gasping, and feeling the need for another shower.

"Who has the OV cards?" he demanded.

"I think I do, but I'm holding too much stuff."

"You need to hurry."

"I know, but I have to do something with all the stuff." This through gritted teeth. My heart rate was still uncomfortably high. "Kids, this is not a playground!"

Why is everything at the bottom of your purse when you need it? "Here, found them… wait, crap, we're missing one-- check your wallet."

A frantic, chaotic search produced nothing.

"Well, where is it?" My husband seemed to have forgotten that if I knew where it was, I wouldn't be searching for it.

"How am I supposed to know?" I snapped. "We're just going to have to buy a ticket."

"I spent all my cash yesterday."

I sighed. "I think I might have some coins. You take the kids and sit down."

By this time, the bus was moving, and I was burning, but not from the sprint. Making a scene in public was not exactly what I had in mind when I thought about integrating into the Dutch community. Not to mention, we had finally purchased an OV card for my husband, and topped it up with 20 euro the day before.

Stumbling around while the bus lurched along, I found just enough coins in my purse for one ticket. It crossed my mind that I might need to start carrying more cash than I used to in the US.

I put the change down next to the driver. He did nothing. Not wanting to be more intrusive that we had already been, I gathered up our pile of things while the bus stopped and a woman boarded the bus. I took a few deep breaths and reminded myself what a hassle a car is in the city.

As we pulled away, I saw that the driver had taken my money, but hadn't replaced it with a ticket. My heart rate began to pick up again, and I recognized that feeling that something in this interaction had gone awry, but I didn't know what. Since moving to Amsterdam, this had become an unpleasantly familiar feeling.

As much as I wanted to walk away, we needed that bus ticket to transfer.

"Pardon *meneer*, I need my ticket."

Thanks to the noise of the bus, and the fact that he turned his head and

refused to look at me, I didn't catch what the driver sneered in response, but it sounded a lot like, "Oh, so now I exist for you?"

I must have heard wrong.

"Excuse me?"

He turned his head towards me. "Now that you need something from me, you acknowledge that I exist?"

What? It seemed my bus driver was throwing a tantrum.

I was far too surprised to be angry, and because I did not want to further upset the bus driver, who seemed to be experiencing a sort of existential crisis, I offered an apology. "I'm sorry, I, uh, I didn't realise…" I trailed off. I didn't know what it was I didn't realize, but I hoped he didn't realise that.

He continued on, and again I couldn't hear him, but it was clear that he was giving me a good talking to.

I stood there for a minute, dazed. "So, can I have my ticket please?"

No answer.

For the love of God, I didn't have time for this. I still had kids to get dressed before our stop.

I turned and walked back to where my husband was trying to keep the kids from kicking each other. Heart rate was back to skyrocketing.

"So he won't sell me a ticket," I told him, and relayed the conversation with the bus driver.

He exaled big sigh. "I'm going to talk to him."

"Have fun."

I busied myself with finishing getting the kids ready and tried to pretend that we got dressed on buses all the time.

My husband came back holding the ticket. "He said 'It's very rude not to say good morning to people.'"

"You've got to be kidding."

Of all the buses in Amsterdam, we had to barely board the one being driven by Mr. Sensitivity.

Maybe he missed the part where we burst onto his bus in a partially dressed frenzy and started bickering right next to him while our kids climbed on the luggage rack? Most people would be glad to be ignored

by us.

I gave an eye roll so enormous I hoped he could see it in his rearview mirror.

I was annoyed. And incredulous.

And, I had to admit, a little impressed. I had just been told off by a bus driver, who considered himself just as important as a paying customer.

We moved from a culture where the customer is always right. Always. Where it is professed that all people are created equal, but it is still socially acceptable to treat bus drivers like garbage.

But now we were in a different culture, where egalitarianism is a way of life, not an ideal. Where ratty bicycles are the great equalizer, nobody can figure out how to form a damn queue, and apparently, bus drivers have feelings too.

I thought back to the chaos of our entrance, and cringed. For all we knew, he might have tried to tell us not to worry about the ticket. For all we knew he might have told us to get off his effing bus. But we didn't know because as far as we were concerned, he was invisible.

Now that was an experience I could relate to. Feeling invisible was the most distinguishing difference between my life in the Netherlands and my life back home. Not understanding the language meant I walked around in a bubble-- an observer, barely a participant in the world. If a stranger made an offhand comment to me while waiting at a crosswalk, for example, it would surprise me. It was as if I was a ghost, and I wanted to say, "Wait you can see me?"

Now I was scoffing at a bus driver. Imagine, he wanted his existence validated.

Imagine.

We came to our stop and climbed off the bus. My kids were curious. "Why does it matter if we say good morning?"

"Well," I began slowly, "it matters to him."

Now when I board a bus, I look the driver in the eye and make sure to say hello. Most of the time they grunt and look bored. But it's a good reminder: they are not invisible, and neither am I.

Donna Bardsley moved to the Netherlands from Seattle in 2011, with her husband and three children. Though she doesn't regret placing her children in a Dutch school, she would rather not relive that first year over again, ever. Her favourite thing about Amsterdam is biking and her least favourite thing is headwind. Most days she has absolutely no idea what she is doing, and blogs about it at Bardsleyland*. She has a very real relationship with Google Translate.*

II

Eating and Shopping

Supermarket woes
Kerry Dankers
Foodlovas

Before moving from Canada to the Netherlands, I must admit that I thought I was a foodie. I started writing a blog sharing my cooking adventures and delicious recipes. I would plan elaborate dinner parties with up to nine courses. I would pair these courses with wines. All my friends were really into it. We would even have themed dinners. Yes, people, it was a foodie's dream world. I had the enthusiastic crowd, brilliant ideas and a grocery store that held anything that my heart desired.

Then I moved to the Netherlands. At first it was bliss. Blue cheese for one euro, Gouda by the wheel and superb wines that were cheaper than water. And that is about where it stops. I faltered. What was I going to make next for my blog post? I decided to write posts about traditional Dutch cuisine. *Stammpot*, white asparagus and mini meatballs were all on the list. This kept me quite interested, but then I wanted to get back to my normal stuff, like finding interesting ingredients and learning to cook them.

This brought me to the Dutch supermarkets. They were small in comparison to their Canadian contemporaries, but I tried to stay positive. I told people that they just had less of each thing on the shelves. I found myself making excuses and brushing things off. Surely I could find baking powder; I was just not looking hard enough. Oh course I would find chocolate chips. Everyone has that! A ham roast? Maybe I was just looking on the wrong days, but there was pork everywhere! A good steak? That was just dreaming.

Soon, I began to give up on my blog. I couldn't find any inspiration. Where was a Buddha's hand when you needed one? For that matter, where was kale in the summer when I wanted to make the latest internet craze: kale chips? Oh, the Dutch only eat shredded kale mashed into potatoes in the winter months. So many new rules, so few ingredients.

And then it went from bad to worse: I got pregnant. Don't get me wrong, I was thrilled about the pregnancy, but I was dreaming about

long aisles of sugary cereals. I would wake in cold sweats knowing that I would never find a box of brightly coloured Fruit Loops in the land of the wooden shoe. Not only did I crave Canadian junk food, I also started being put off by the smell of Gouda. Did you know that the only hard cheese in Holland is Gouda? I would have done anything for cheddar or a nice block of mozzarella. Ah, the woes of pregnancy.

Fast-forward three years, and you can still find me pining away for my sugary cereal, root beer, some good Chinese food and cheddar. My cravings have subsided, my cunningness in the grocery store has heightened, but finally I have succumbed to the boring food of the Dutch. The funny thing is, I know when I move back to Canada that I will be throwing my hands in the air and cursing the sky when all I am trying to find is a Turkish pizza shop or a *jong belegen gouda*.

Kerry Dankers is an ex-Olympian Canadian speed skater who up and left her own country to live a Dutch adventure. Two kids, a new language and her husband's PhD later, her time is up and she is returning to the homeland. Four years of going Dutch has left her a more assertive, cheese-loving, penny pincher, but she will never travel without brown sugar again. Although Dutch food has been the demise of her food blog Foodlovas, *you can still find her cruising on her bike with two kids strapped on, sans helmet, living the Dutch dream in Canada.*

Dutch chorus at the checkout
Marianne Orchard
Like A Sponge

Spinach was two for one this week. I needed spinach too, but decided that a kilo of spinach would be pushing it, given that I'm the only one in the house who likes that stuff. At the till, the cashier said, "You know they're on sale, don't you?"

"Yes," I said, "but I decided two bags would be too much."

There was an audible intake of breath from the women in the queue behind me. Then they turned into a Dutch chorus.

"Why don't you freeze it?" said the woman behind me.

"Freeze it! Freeze it! Freeze it!" sang the chorus.

"My freezer is full. Oh woe is me," I replied.

"Can you freeze spinach?" said the cashier. "I only use jars. My mother never taught me how to cook spinach."

"Cook it! Cook it! Cook it!" sang the chorus.

"Nothing wrong with eating spinach twice in a week," said the woman in the queue behind me. I consider myself reasonably no-nonsense, but there is always a Dutch person around who can out-no-nonsense me without even breaking into a sweat.

"Nothing wrong. Nothing wrong. Nothing wrong." sang the chorus. Could they really be placing their shopping on the conveyor belt in unison? I became preoccupied with packing my bags.

"Don't you have anyone to give it to?" said the cashier, who has lived in the village all her life and knows everybody.

"Give it away! Give it away! Give it away! Give it away now!" sang the chorus.

I focused on packing my bags. It dawned on me that no I don't have anyone here I could give a bag of spinach to. My spinach beneficiaries, as in my family, are far away. I felt a bit pathetic.

"My kids love spinach," chipped in another member of the Dutch chorus further down the queue.

"Love spinach! Love spinach! Love spinach!" sang the chorus.

My kids don't like spinach either. I felt even more pathetic.

"I don't' know how to cook sprouts," said the cashier suddenly, still on the subject of cooking vegetables.

"Cook sprouts! Cook sprouts! Cook sprouts!" sang the chorus.

I do know how to cook sprouts. And I do know about supermarkets and their sneaky ways of passing discounts on to the producers. And about how much food is thrown away each week.

I shoved the bloody spinach in my bag, paid and slunk off home.

Marianne Orchard left Britain an eternity ago to study in Germany. She met her Dutch husband there, and moved with him to the Netherlands. They now live with their two children in a village in Friesland. Marianne works as a Dutch-English translator, and writes about the Dutch and English languages on her blog Like a Sponge.

When food gets lost in translation
Damini Purkayastha
The Tini Times

The first Dutch word I ever learned was *kip*. Five minutes before we reached the Albert Heijn (technically we were still at home because Delft is so small) my husband figured this was the one important thing I should know. Faced with aisles full of groceries labelled in Dutch, all I really needed to keep in mind was that chicken would henceforth be *kip* in my life. Funny how a universally consumed product like chicken has so many different names: *pollo, poulet, murgi, kip* and *Huhn* to name a few.

Not that it worried me. I was looking forward to all the new culinary experiences ahead. Food is probably the only thing in life I am adventurous about. Well, that, and commas. I do live on the wild side when it comes to commas.

Thankfully, not having allergies or reservations about food ensures that I am never a fussy traveller and rarely an unhappy eater.

As I began my maiden voyage into the Albert Heijn, nothing could faze me. I wanted to fill my blue basket with Dutch ingredients, ready-to-eat meals I had never heard of and all sorts of meats. I was ready to expand my repertoire of foodie knowledge to include a cuisine that hadn't become a global phenomenon yet.

It wasn't until two minutes after the shopping had began that I came to appreciate how important language could be for the whole experimentation thing.

I knew language would be a barrier in the job hunt, when reading the news, or even while watching TV, but food packaging is moron-friendly, isn't it?

Turns out, it's not. If you don't know that the Dutch word for sugar is *suiker* or that salt is *zout*, you can walk down the correct aisle a thousand times and still come out empty handed. That night, I bought the most boring, basic edibles: *kip*, rice, a few recognisable vegetables, milk (because *melk* is an easy translation) and went home.

In the ensuing days, I came home with pasta sauce with beef (my husband doesn't eat beef), brown bread that was actually raisin bread (I hate raisins), interesting-looking cheese that turned out to be super-aged cheese for which I had yet to acquire a taste and a delicious-looking dessert that was nothing but a globoid of cream.

My husband's birthday was about two weeks after I arrived in Delft. Completely forgetting that shops shut at 18:00 (something I'm still not used to), I ventured out to buy cake much too late. My only options were the C1000 and Albert Heijn, and I wasn't sure if I had noticed any cake there. I reached the store and asked one of the managers if they had any cake.

Here's how that conversation went:

AH Guy: What's that?

Me: Cake? Birthday cake?

AH Guy: I'm sorry, but what is that?

Me: <enacting a birthday party, cutting cake with my fingers, blowing candles, mumbling happy birthday...>

AH Guy: <flailing arms helplessly>

Me: Come on! <start singing loudly> "Happy birthday to you... happy birthday to you..."

At this point, another AH salesperson came running to help me out before all psycho alerts went off. He also explained that cake is always named after its main ingredient. So, a chocolate cake is a *chocoladecake*—one word, pronounced all together. An apple cake is an *appeltaart*, and so on.

As I settled in and met new people, I made the reassuring discovery that this wasn't an experience unique to me.

One friend, who is trying very hard to be a vegan, spends an average of an hour buying groceries because she had to read each and every label with the Google Translate app running on her phone.

Another, who is allergic to certain nuts, avoided buying anything nutty until she could get a hang of the language. She still doesn't eat any *borrelnotjes* (a mixture of nuts served with drinks), nor does she buy any baked goods unless she's 100 per cent sure.

Of course, it's not just the food; the experience of shopping itself changes when you learn the magic words such as *bonnetje*. That's the day you stop looking at the cashier like a moron when she asks you if you want the receipt.

Yet another friend tells me that sometimes knowing the language a little bit can be trickier. Usually social, she enjoys chatting with cashiers as they total up the bill, especially when there are a lot of groceries to scan in. Turns out, when she finally learnt enough Dutch to strike up a conversation; it didn't go quite as planned.

"I had gone to AH after an hour at the gym, and was still in exercise gear. I sighed deeply and told the lady behind the counter that going to the gym had made me very tired. She stared back at me with the strangest look on her face. Turns out, I had mixed up a few words. The word for 'tired' is *moe*, but the word I had used was *mooi*, which means 'beautiful.' So, what I had actually told her was that going to the gym had made me very beautiful," she said.

Oops.

I once bought a meat pie from the farmer's market. The stall owner mumbled some instructions at me. I nodded vigorously, catching words like magnetron here and there. I assumed she meant I needed to heat the pie before serving it. So I did. What I served wasn't pretty. It was a leathery, chewy lump. Turns out, I wasn't supposed to heat it in the microwave, but in the oven. To be fair, anyone with a modicum of baking experience would probably have figured that out.

Thankfully, unlike in other European countries, most people in the Netherlands actually do understand English and are happy to help out. I once wanted to buy turmeric, but couldn't remember the Dutch word for it. About four store attendants stopped whatever they were doing and chatted with me until one of them hit upon *kurkuma*.

A few months ago, I wrote an article on a Dutch Christmas tradition called *gourmetten*. It's a raclette grill with mini-plates set in the centre of the table, while families sit around and chat over a *gezellig* meal. I learned about *gourmetten* just in time for my second Christmas here. Only after that did I begin to notice *gourmetten* sets on sale everywhere, meats packaged for the gourmetten and recipes for the meal.

My sudden awareness of something I was obviously blind to the previous year made me wonder how much more was hidden from me, simply because my brain didn't care to observe unfamiliar words.

What if somewhere out there is a Dutch chocolate cake, layered with dark chocolate, chocolate chips, whipped cream, chocolate mousse and a secret chilli chocolate recipe that a baker's great-great-grandfather had learned from his Mexican lover? It's probably called *zwarteslagroomnoirpiccantechocoladevlaai* and my ninny brain has been ignoring it all these years! I stay awake at night thinking of all the yummies I may have lost in translation.

It's not just about eating. Understanding and appreciating local cuisine is a key aspect of understanding a society and its history. During my interviews about *gourmetten*, I learned the concept of *gezellig*, one of the few Dutch words that have no English translation. It could mean anything, from a warm dish to a cosy family get-together or a comfortable ambience.

While researching Dutch history for another article, I spoke with food historian Peter J. Rose, who has written extensively on Dutch cuisine among Dutch-North American families. One of her books, *The Sensible Cook*, is a collection of recipes that Old Dutch families carried with them during the first wave of immigration. "It is remarkable how the foodstuffs of the Dutch and their customs were retained for centuries," she said. "When they adapted new dishes, they gave them a Dutch twist. For example, to the cornmeal mush of the Native Americans, the Dutch settlers added milk. It became a standard porridge for the evening meal."

Stamppot, one of the most popular modern-day Dutch dishes, is as practical as the Dutch are now famous for being. As I was writing this piece, I came across a number of dishes that didn't seem quite as straightforward. I briefly considered giving the rather complicated *draadjesvlees* Pie a shot, but brushed that thought aside fairly quickly. You see, the recipe called for a lot of slow cooking and patience. While I have all the patience in the world to consume all sorts of food, I have next to none when it comes to cooking it.

Damini Purkayastha is a freelance journalist with publications in the Netherlands and abroad. Having moved to Delft from New Delhi in 2012, she's slowly coming to terms with biking, rain and the Dutch predilection for agendas. Damini believes that the history of a nation is inextricably linked to the food on its plate. Which is probably why you can usually find her at a local cafe doing cultural research. Read more about her (mis)adventures at The Tini Times.

The Dutch and their coffee

Tamkara Adun

Naija Expat in Holland

Coffee is an essential part of Dutch life as the Dutch have brewed and drunk coffee for centuries. Coffee beans were first discovered in Ethiopia many centuries ago, and were cultivated and sold only by the Arabs, who tried to maintain their monopoly on the market by preventing the exportation of live coffee seedlings. By the turn of the 16th century, through shrewd and crafty means, the Dutch succeeded in obtaining these live coffee plants and became the first to successfully grow coffee beans in greenhouses.

Thus began the foray of the Dutch into the large-scale cultivation and trading of coffee in Europe.

Why this bit of ol' history you might ask? Well, this interesting bit of history may very well explain the Dutch affinity for coffee.

As an ex-Lipton loving gal' living in the Netherlands, I am gradually coming to an appreciation of the Dutch culture as it relates to coffee, and to coffee itself as an amazing beverage with an aroma that makes me all warm and tingly. For to what can one compare the rich scent and taste of a freshly brewed pot of coffee? I find myself slipping away from the tea side of life to the darker and more exciting side of coffee. Who would have thought? Me, the self-acclaimed, dyed-in-the-wool tea drinker!

Dutch culture and coffee go hand in hand and I will give you three reasons why.

For starters, when invited to a Dutch dwelling, you can usually spot a high profile coffee machine, the kind that can brew a wide range of espressos, lattes and cappuccinos. Then you are promptly served a nice hot cup of coffee with which your host or hostess will usually offer you one solitary cookie…not two or three but one.

Second, when Dutch people have something of import to discuss, they speak in terms of going for coffee, as opposed to having a chat or conversation. It is quite normal to hear "Shall we go grab some coffee?' when an important issue is about to be discussed. It took some getting

used to these discussions under the guise of coffee drinking and now when I want to broach a difficult discussion, I think of coffee. Where I come from, we are more disposed to saying things like "I would like to have a word with you" or "I have a bone to crack with you."I believe I would much rather have a cup of coffee than crack a bone!

Third, and the weirdest thing surrounding the Dutch and their coffee, is the difference between a "coffeeshop" and a "café" in the Netherlands. Sounds like the same thing? It's not at all, not by a long shot. In the Netherlands, "coffeeshop" (or *koffiehuis* as it is called in Dutch) and "café" are as different as night and day.

A coffeeshop is an establishment licensed to sell cannabis and it usually has a green and white sticker on the window which is its license to operate, and also signals to tourists and visitors what to expect should they decide to step in. A café on the other hand, is a restaurant or bar where you can grab a coffee and a light meal.

It goes without saying that I stick to the cafés. The strangest thing for me though is that suddenly tea seems mild and sans aroma to my newly sensitized nostrils. I still have tea once in a while…after all, someone has to drink the stash of green teas that I have accumulated over time. The sign that I have fully migrated and made the 180° switch to the coffee side of life is when I can chug down those tiny cups of espresso without wincing.

Tamkara Adun moved to the Netherlands from Nigeria in 2013 with her husband and two children. She manages a blog at Naija Expat in Holland, *where she shares her thoughts on expat life in The Netherlands as she juggles work, study and family in her new location. She is currently studying for her MBA at the Rotterdam School of Management, Erasmus University and is a contributing writer at* Women of HR. *You can connect with her on twitter* @tamkara. *Tamkara is an ardent lover of family trips, social media and great food. A few hours of blissful solitude as she digs into a great book is one of her favourite things. She looks forward to a day where trailing spouses no longer feel the need to trail but would rather blaze a trail.*

III

On Two Wheels

Getting from A to B
Caitlyn O'Dowd
Olympic Wanderings

I gripped the handlebars and tried to listen to my boyfriend. "Just put your foot on the pedal, kick off and swing your other leg over," he explained patiently.

I peered up from my handlebars to his kind face. He must have seen the terror in my eyes, because he continued on, removing my bike from my white-knuckled grip and demonstrating effortlessly.

I couldn't concentrate. All I could think of was the last time that I had ridden a bike. I was never particularly good at the whole cycling thing, but on this particular day, I momentarily forgot about those wonderful inventions called brakes at quite the crucial moment. I ended up crashing into a bike rack, with all of the bikes in the rack falling on me and trapping my ankle. A couple of weeks on crutches sealed the deal. My relationship with my bike was over.

"Caitlyn!" I heard. It was my boyfriend, bringing me back to the present. There we were, in what was figured to be a spot where nobody could see my cycling lesson. We were in an old *hofje*, a type of communal courtyard, only a few hundred metres away from our apartment. The home that we'd shared for ten whole days in this quirky little country on the other side of the world.

I had held out for ten days. I was confidant that I could live in this country—on a pedestrianized street, and without a driver's license, no less—and not ride a bike. I would be a walker, I decided.

But then we went over to Paul's grandfather's house for a visit. We caught the bus, which surprised the 84-year-old. Trying to defend myself, I asked him if he ever rode a bike. It was low, I know.

"Only when the weather's nice," was the reply.

Oh hello, I thought, seeing the February drizzle outside out of the corner of my eye. I might have an out here. I could definitely push this out to the spring, at the very least.

"Like Thursday," he then continued. "Thursday was nice, so I went for

a ride."

Apparently, you never forget how to ride a bike. I believe that, and I can say that it is correct. I remembered how to ride a bike. I could stay upright, turn corners, break and even figure out the whole gears situation—that is, after mastering how to get on. That took a while.

My bike was a pretty bike. It was one of my boyfriend's sister's (yes, people in the Netherlands own multiple bikes) and it was quite dashing indeed. It was a town bike, like 95% of the bikes here. You sit up as if you're on a desk chair, with a great view of what's in front of you. Hardly anyone wears Lycra or a helmet.

However, I never knew until I got to the Netherlands that I'm short. I knew that I was the shortest in my family, yes, but my family isn't particularly short. The Dutch just happen to be the tallest people in the world, bar none, for some reason. Yet they're still no good at basketball, but I'm digressing.

So, bike makers go for averages, and made my pretty bike fit for a giant. The seat came up to my waist, and I had no understanding of how I was to leap to such great heights and simultaneously push off.

It took a good 45 minutes for an audience to appear. All of a sudden, the quiet little *hofje* wasn't so quiet anymore. It was as if somebody living nearby caught sight of me and started the rumour in the neighbourhood. "Hey, come on over to my *hofje* and see the foreigner who can't ride a bike!" A crowd began to gather, utterly perplexed at my predicament. These are people who are pretty much born with a bike between their legs. Watching me on my little pretty bike was the equivalent of seeing a teenager learn to walk.

They yelled out words of encouragement, but I didn't dare look any of them in the eye. I was mortified and the situation felt hopeless. When Paul held the bike, I could scramble up and I was fine, but it's not like I could call on that type of assistance at every traffic light. I eventually used a curb for a bit, before shakily mastering the art myself.

Boy, was I relieved to find out that I remembered how to ride a bike. I'd had awful visions of me needing training wheels.

"*Gefeliciteerd*!" shouted one man from the crowd, after I successfully completed a lap of the *hofje* completely unaided. I'd given him his

Sunday entertainment.

In my hometown of Melbourne, I would never ride a bike. I'm scared of the motorists, mainly. In the Netherlands, cyclists seem to be the top of the food chain. We have right-of-way at roundabouts, our own sets of traffic lights, separate bike lanes and motorists driving at a snail's pace in the city centre.

Practically newborn children sit in little seats on handlebars, and toddlers get pulled along in little carriages either behind the bike or built into the front. These aren't weird things you see. They're everywhere. My boyfriend used to get dropped off to school in one of those carriages, until he was big enough to ride his own, of course.

These days, I cycle anywhere that is more than a five-minute walk away. I own two bikes: a clunky *omafiets* that sounds like someone thumping an old rubbish bin when I ride it, and my new, pretty bike. Yes, I must use the past tense to describe my old bike, as it was stolen approximately a year after I moved to the Netherlands. I was devastated, but my boyfriend congratulated me. "Now you've properly integrated," he remarked proudly.

Finally, I am confident on my bike. At least, except for that time it got stuck in the tram tracks. That was pretty embarrassing. Oh, and that time when a friend decided it would be oh so much fun to cycle through the sand dunes, lending me her bike fit for a professional basketball player. That was quite awkward.

But yes, now I'm awesome. I can even stop at traffic lights and go again when they turn green.

Well, about half of the time. The other half of the time, I miss my starting push-off again and am stranded on the wrong side of the road, with dozens of other cyclists zooming past and tut-tutting me. I hold my head high, patiently wait for the light to go green again... and silently wish that I too had been born with a bike between my legs.

Caitlyn is a twenty-something Australian living in Dordrecht in the Netherlands. Seven years ago she crammed her life into a backpack affectionately called The Beast and hit the road, anxious to see all the world's Olympic sites. Needless to say, she got a bit distracted along

the way. Today she's a tour guide on river cruises through Europe, and blogs about what she loves at <u>Olympic Wanderings</u> about travel, sport and food.

To cycle or not to cycle, that is the question
Renée Veldman-Tentori
Dutch Australian

Growing up in Australia, I was one of the few children who couldn't ride a bike. Our family literally lived on the side of a mountain, in a beautiful rural town. With a steep driveway from our house to the street, very narrow, winding roads and a substantial distance to the nearest town, it wasn't at all practical to cycle. In fact, I rode a horse around our 25-acre property, caught the bus 45 minutes each way to the local school, and, to get anywhere else, travelled with my parents in the car. I do remember trying out a friend's bike once or twice on a very steep slope, and giving up after a fall. There was very little need or opportunity to cycle.

Again, there was little question of cycling after I left home and lived in Brisbane. I caught a ferry to work, loving the breeze through my hair as I stood on the front deck of a catamaran cruising down the Brisbane River. In the winter, I chose to travel by bus, and eventually gathered together the courage and savings to get my driver's licence and a car. Over the years, there was some encouragement from the local council to get people to cycle more. However, the heat and humidity, compulsory helmets and often-dangerous cycling conditions in traffic and, maybe, a little laziness, deterred me.

Fast-forward to 2002, when I moved to the Netherlands to live with my Dutch then-boyfriend, now husband. On my very first day in the country, he arranged to pick up a bike for me from a friend. I found it kind of amusing, and rather frightening, as this was not something we had previously discussed. It seemed in the Netherlands, there was no question. You simply cycled.

I was terrified at first. Trying to follow him through Delft's bumpy cobbled streets, precariously balancing not only on the bike itself, but also between a truck and a canal! Once my boyfriend realised I was a total novice on a bike, I was given some lessons on a quieter street and slowly built my skills and confidence.

Before too long, I was cycling like a local. You should have seen what

I could manage to balance on my bike after a grocery shop at C1000 or Albert Heijn! No matter how good I got, though, I'd always be outdone by someone else. I've even seen a TV, Christmas tree and mattress transported on a bike. No, not at the same time, but still individually very impressive.

The ease and flexibility of being able to cycle was something I grew to love. The extensive bike path network, mostly keeping you safely away from cars, buses and trams is one of my favourite aspects of cycling in the Netherlands. Sure, you still have to listen out for the *brommers*, mopeds that speed up behind you along bike paths but otherwise you can usually just cycle along without a care in the world.

Well, that's during the spring and summer, as even the amazing infrastructure cannot assist with the Dutch weather. There are rather a few windy, rainy days that severely limit the pleasure of cycling. From time to time, it can be near impossible in gale force winds that threaten to blow you and your bike into the canal, where you would apparently join a huge number of bikes that are pitched into canals each year.

That brings us to another point crucial to the cycling culture. Several people have told me, quite seriously, that your bike lock and chain are often almost as valuable as the bike itself. I was lucky, though. From 2002 through to 2007, I managed to live and cycle daily in the Netherland with only a few incidents. My bike has remained loyally waiting in whichever location I had left it.

My bike did attack me once, the chain eating up the bottom part of a favourite pair of jeans. Afterwards, I learned that you can purchase metal clasps to keep long trousers out of harm's way if you have an exposed chain. Another day, I am sure the bike threw me off like a bucking horse and I hit the ground hard. I grazed my elbow badly on the gravel, where a scar still remains today. In retrospect, it may have been the gin and tonic I'd been drinking previously at a picnic that affected my balance, but I'll blame it on the bike.

Cycling became a part of my everyday life and there was no longer a question not to cycle. Right up until two weeks before I gave birth to my first daughter, in July 2007, I went just about everywhere I needed to go on my bike. My labour went relatively smoothly, and it may well

have something to do with my fitness level from so much cycling.

From 2007 to 2012, our family moved back to Australia. After being on bikes so regularly in the Netherlands, we were keen to continue cycling. However, cycling again became a question in our new home in Brisbane. With a baby, busy roads, limited bike paths and often lots of things to carry, we decided against it. Later, we moved to the suburbs and were excited to again see lovely meandering bike paths. I purchased a bike and a baby seat. Then I used it about 10 times in a year. We also bought a bike trailer, which sat unopened in the box. It was just so much more practical to use the car to get around.

Finally, we've come full circle. We're living in the Netherlands again. Our girls received bikes from their Dutch cousins on the day they landed. Turning three and five the week we arrived, they were at a perfect age to race around on their little pink bikes with flags and training wheels. For school runs, especially as the weather grew colder, I tucked them into a bike trailer complete with a blanket. We've cycled through all kinds of weather: sunshine, wind, rain, even snow. We park our bikes alongside more than a hundred others at school each day.

This time around, I did obtain a Dutch driver's licence and have been cheating a little with the bikes locked in the shed until the temperatures reach at least double figures. Any day it's warm enough, though, I'm sure the question from my children will be "Mama, can we cycle to school today?"

Renée Veldman-Tentori is a Dutch Australian who has spent the last decade living between the two countries. She is a professional parent constantly seeking the perfect family work balance and a social media trainer who loves to connect, share, learn and teach. Renée blogs on Dutch Australian.

I fought the law and the law won
Zoe Lewis
George With Ears

Let me tell you a story about a reasonably competent woman, bicycles and the law. The law of gravity.

Anthropomorphic manifestations play a rather large part in my life. We all know Death, the tall skinny dude who wields a scythe, looks good in black, turns up at awkward times and has few social skills. Well, let me introduce to his lesser-known friend and my personal nemesis, Gravity.

Gravity and I have had a tricky shared history. She (and I see her as woman as only a woman can be this much of a bitch) seems to have taken a very personal dislike to me at birth. Gravity has spent the last 30-plus years kicking my ass at any given opportunity. I was a gangly youth, with all the coordination of Bambi on ice, who segued into an unfortunately clumsy adult giving up all hope of growing into her body years ago.

We've had a love-hate relationship. Me, assuming that simple ambulatory tasks are a thing I should be able to do, Gravity disagreeing. The wounds she's inflicted on me have taken their toll over the years, weakening joints and rendering various ligaments about as elastic as an over-loved pair of leggings.

I'm probably the only person in the world who can trip over perfectly flat surfaces. Inanimate object appear out of nowhere to become intimately acquainted with my feet, introducing me to the floor with all the enthusiasm of a basket full of puppies. I lie there in shame, looking up at the poor unfortunate who happens to be my companion at the time, shaking their head in disbelief, trying to find the source of my sudden change of orientation and deciding whether laughter or concern is the right course of action.

It's also possible I've enabled Gravity over the more adult portion of my lifetime. Stupidly, I introduced her to her best friend, Alcohol. Together, their machinations have seen me on my way to more emergency rooms than a regular on *Grey's Anatomy*. Divided they are menacing, united they are Legion! It's Biblical. I can only imagine how they must have

chortled when I moved to the Netherlands, and their glee the first time I decided I should have a bike of my own.

I still remember the look on my (then) boyfriend's face at the end of a night out together, me and my new(-ish) mode of transport, with Gravity and Alcohol riding pillion. His look of utter bewilderment at my ineptitude as I lay there sandwiched between the road and my bike was mortifying. He truly couldn't fathom, in all his Dutchness, how I could consistently go from vertical to horizontal with such startling regularity, and grace. This is my story and this is how I choose to remember it.

You see, the Dutch are born with a bike up their arse. It's innate. They are born, learn to crawl and then on to a bike, I kid you not. Toddlers who can barely stumble along are whizzing around on a *loopfiets*, a small bicycle with no pedals where they literally walk and glide. They have a bike in every shape and size and for every demographic. It is not uncommon to see entire families riding one bike, with an attachment at the back for the dog.

People move house with only a *bakfiets*, bike with a container on the front that varies in size from a modest wheelbarrow to a truck size flatbed. Like the Beverly Hillbillies, it's only a matter of time before I see one with Grandma in her rocking chair mounted to the front. You name the activity; they will make a bike to facilitate it. It's genius.

My husband (not the aforementioned boyfriend) still treats me like a small child riding a bike for the first time. He shadows me, always riding on my left, forming a human shield between the traffic and me, should Gravity decide to start throwing her weight around. He will paint this as chivalry or just being social but I know better—it's a precaution. So many times I have limped home after a night out with Gravity and Alcohol, to be greeted with a raised eyebrow, a small shake of the head, a chuckle and "Oh, honey."

One particular incident involved more than a few glasses of wine, a slow ride home and a brick. Alcohol did his best to thwart any type of self-preservation instinct, rendering my ability to simply place my feet on the ground null and void when I clipped the brick and started my slow descent to sea level.

So, here I am, wedged in a pile of sand, sucked ever deeper into a vortex

of discarded cigarette butts, beer cans, and dog pee. Out of nowhere a woman appears. "Would you like some help, dear?" Her voice is filled with pity and genuine concern, unsure of how I could possibly have gotten myself into this predicament. I reply with a mumbled "Yes." All of my caustic wit and sarcasm is gone. Had I left it in the café or had it just fled as I flew through the air?

"Oh, you're English?" The reason behind my current situation becomes blatantly obvious to her in an instant. She picks up my bike, dusts me off and waves me off with a cheery "Be careful!"

Once more, Gravity had done her work. In the slowest and most anticlimactic of bike crashes, I had somehow managed to totally tear the ligament in my ankle. Yes, it needed surgery. Yes, I left it for ages before getting it checked out. No, I didn't learn my lesson.

The one thing I did insist on when it comes to bike safety is a helmet for our daughter. My husband seriously thinks I am being over-protective, socially handicapping her in a society that does not wear helmets. She is two.

I am protecting her from me. I am not a total tit; I would never ride my bike with her on the back when I have had a drink. Even so, the first time I took her on the bike is etched in my memory forever. The feeling of utter vulnerability, of being ready to wrap myself around her and take the hit in a fraction of a second, is as fresh today as it was then. How in the hell do these people do it with three kids? Confidence is the trick, and the Dutch have it in spades.

I'm an excellent driver, really I am. I can drive anything with wheels, from tanks (seriously) to trucks, trailers to a motorbike. I can park a Volvo in a matchbox. I've navigated some of the busiest places in Europe, from Berlin to Brussels, where you drive your car like you stole it. The Netherlands, however, took things to a new level.

The Dutch think they are bulletproof. They launch themselves in front of vehicles with a supreme confidence in their ability to fend off the two tonnes of screeching metal careening towards them. They remain utterly oblivious to the tirade of white-knuckled expletives I yell as they are texting or chatting with friends while cycling, riding two or more abreast, holding up traffic or riding the wrong way up a one way street, impervious to the dirty looks I am trying to laser through the back of

their heads. Basic traffic rules and Gravity do not apply to them. They are her children.

There are over 16.5 million people in the Netherlands, and do you know how many bikes there are here? Neither did I, so I Googled it. Over 18 bloody million. I am fairly sure that most of them are on my street, on the way to every appointment I have and leaping out at me from every drunken corner. Of that 18 million, I would imagine a fair number are at the bottom of canals or decomposing under a pile of other bikes.

I was treated to a new bike recently, as in just out of the box new. I was giddy. My husband came home, looked it over and stated it was very new looking, suggesting we scratch it up a bit or add some stickers to make it less new, and thus not so appealing to sticky fingers. I was horrified.

Bike theft here is an industry. Ownership is implied by three locks and it being parked outside your front door, however that is no guarantee that the local miscreants feel the same way. A friend recently pointed out it isn't the strength of your lock that helps retain ownership, but the quality of lock to bike ratio. Make your bike appear so crappy that the effort involved in the theft is too high. "Look! The bike parked next to it is much prettier and easy to ride off on." Camouflage and misdirection is what it's about.

The Dutch can evaluate all of this in the blink of an eye, impervious to Alcohol and his tricky ways. So I now lock my bicycle to my husband's heap of crap (two flat tyres for the past three months) and our decomposing bench, and hope for the best.

Gravity seems to have moved on to newer pastures these days. She still likes to keep her hand in, especially when Alcohol and I go out, but I have learned that walking is way easier (for the most part) and it is much less likely to end in surgery. Still, it vexes me to see the Gravity-defying skills of the Dutch. As the mother of a newly minted Dutch person, I hope she models her relationship with Lady Gravity on her father's rather than mine.

Zoe is an English woman married to a Dutch man with a lethargic Spanish greyhound and Machiavellian two-year old. A social hand

grenade with two blogs, (because one just wasn't enough work) taking on life one grammatical error at a time. Find her at George With Ears or The Sleazy Bakeshop.

How to steal back your stolen bike
Kerry Dankers
Foodlovas

The Dutch have bikes locked up at multiple train stations that they frequent. They have junky bikes that rattle, *mamafietsen*, or bikes with baby seats, racing bikes, hipster bikes and cargo bikes to carry babies or Ikea furniture.

Although bikes are so common in this country, they have lost their value as a personal good. It's hard for an outsider to comprehend, with myself being firmly in that group, but somewhere along the way it became acceptable to steal bikes. Maybe it's because everyone has several or maybe it's because most are on their last legs, but somehow, this mindset had my mother-in-law defending the thief instead of the victim.

"Well, you left the key in it, didn't you?" she argued. "Then it's your fault." Did I mention that she is Dutch? I've always thought that when you own something, it belongs to you and no one has a right to it—even if the damn keys got forgotten in the lock. When it comes to stealing bikes in the Netherlands, this rule does not apply.

One day, my family and I were returning from the grocery store. We parked our bikes in front of our house. It's a bit tricky because the sidewalk is so narrow. That day, it was made even harder by a massive green van parked parallel with the sidewalk looming over our sidewalk space. I leaned my bike against the wall, unbuckled my kid and took her in. My husband's saddlebags were both bursting with groceries, so he parked using his kickstand and trekked in a few loads. We got carried away putting everything in the fridge and cupboards before my husband remembered to move his bike and lean it against the wall, in case a tiny human decided to try to squeeze between the bikes and the annoying van. He walked back into the house and then walked back out again with a puzzled look on his face. Patting his pockets and starting to panic, he said, "I think someone just stole my bike!"

"What?! When?!" was all I could muster. I jumped up and had to take a look myself. I was certain that I would see it. Maybe a neighbour had just moved it around the corner or something.

It was gone. Being the Canadians that we are, we were hurt to the core and truly offended. We were gutted, since the key wasn't removed from the handy wheel lock during the hustle and bustle of getting all our crap into the house, toddler included.

Down one bike, my hubby started riding an old granny bike that we had in the shed for guests. Besides being mortified that he failed to remove the key, he was perfectly happy riding the tiny bike that rattled like crazy and was in danger of blowing out his knees. He figured there was no way this old thing would get stolen, and that gave him his tiny shred of peace.

I, on the other hand, went on a rampage. There wasn't a single bike stand that I walked or biked by that I didn't pore over searching for my husband's purple bike. See, this bike had a few unique features. It was a man's bike with a high top bar, and it was black and purple. Purple is not only an unusual colour for a man's bike, it's also not very popular in the land of grey and taupe.

Another feature has to do with the unique human that is my husband. He thinks himself a man of many talents. I have to reluctantly agree with him on this front, as he is an Olympic medallist and has a doctorate of engineering, but the root of his many talents mostly has to do with being cheap. He likes to blame it on being green, but I have my doubts. This is the reason his bike had a giant glob of epoxy clinging to his brake wire. He fixed it. It worked. It was ugly. It was free.

So there I was, searching high and low for a purple man's bike with a telltale glob of epoxy close to the handlebars.

Months went by. My inner fury of being wronged was dampening, but my eyes never rested as I walked the streets running errands. Once, my heart stopped as a flash of purple hit my retinas. "No. Way. I. Found. It." Upon closer inspection, no glob of epoxy was present. My heart started to beat again.

One day, it really happened. It was a grey and misty morning. The clouds were low in the sky and...enough bullshit. It was crap weather and I was miserable, walking with a plastic-covered stroller to the closest over-priced supermarket. While I was getting soaked, my eyes scanned every bike I passed—and there it was, leaning against a

chain-link fence in front of a high school. I quickly ran over. Purple, check! Epoxy, check! "OMG, this is our bike!"

I ran back to our house absolutely losing my shit, as my brain flipped through options of what to do. Since we didn't have a spare key, the brilliant plan I came up with was to lock the bike to the fence with one of our locks, attach a note saying that the bike was stolen and belonged to us, and could he/she kindly leave the key in the wheel lock for us to pick it up. Did I mention that I am Canadian?

As I was doing just that, the school's security guard came out. "*En wat doe jij?*" he asked, wanting to know what the hell it was that I was doing. I responded enthusiastically and in English, "This is my bike! I found it! It was stolen six months ago!" He completely believed me. It might have had something to do with the stroller containing a one-year old. He instructed me to stay put and hurried into the school.

Minutes later he returned with massive lock cutters. No, he did not have them raised above his head, snapping them open and closed in celebration. He tried his darnedest to cut the lock, but to no avail. I thought our impossible mission had failed, but he was not about to give up. He grabbed the bike and carried it into the school. I followed him with the stroller and an eerily quiet toddler. She definitely sensed the gravity of the situation. She's smart like that.

The man told the people at the front desk what was going on. Although I was not fluent in Dutch, I am fluent in hand gestures and scowling. No one believed my story. The man was unfazed. He had become my rock, my partner in crime. He disappeared while I waited patiently, getting dirty looks from staff and confused looks from the students. No one noticed my ridiculously cute and well-behaved child. Nobody notices kids in the Netherlands.

What seemed like an eternity later, the man returned with a student decked out in coveralls and brandishing a circular saw. No, he was not holding it up, revving it in celebration. Right there, in the middle of the school entrance, the boy cut the lock. It was incredibly loud, sparks flew everywhere, and, basically, it was fantastic.

Problem solved, I profusely thanked everyone. I fumbled with how to roll the bike and the stroller home at the same time, only to find out that

the back wheel wouldn't roll because the derailleur was mangled. Why in God's name was I stealing back this piece of junk?! Spite, people. Spite.

In another unexpected move, the hero of this story, the security guard, picked up my bike and carried it five blocks back to my house. I hugged the man. Then I promptly locked up the piece of shit bike.

Kerry Dankers is an ex-Olympian Canadian speed skater who up and left her own country to live a Dutch adventure. Two kids, a new language and her husband's PhD later, her time is up and she is returning to the homeland. Four years of going Dutch has left her a more assertive, cheese-loving, penny pincher, but she will never travel without brown sugar again. Although Dutch food has been the demise of her food blog Foodlovas, you can still find her cruising on her bike with two kids strapped on, sans helmet, living the Dutch dream in Canada.

IV

The Throaty G: Learning Dutch

First Dutch language impacts
Ute Limacher-Riebold
Expat Since Birth

We moved to the Netherlands when our son was two-and-a-half years old. We all considered moving from Florence, Italy to The Hague to be a big adventure. Personally, as an expat-since-birth, I like to move, but this was our first move with a child. We wondered how our son would cope with this. He found it quite interesting. He loved the seaside, riding in a tram, the green parks and the fact that there were playgrounds everywhere! But would he learn the language? Would he be able to make local friends like in Italy?

When we arrived in the Netherlands, we signed our son up for a Dutch daycare in order to help him settle in as soon as possible. We were excited to meet new people and to learn a new language.

Unfortunately, the first daycare was quite a shock for all of us, as the *leidsters* (teachers) were not used to multilingual children at all and didn't know how to make him feel comfortable in his new group. The after-lunch feeding of the birds in the playground was especially scary for him. I don't blame him, as they would feed the leftovers to enormous seagulls. Our son was so scared of these huge, greedy birds that he didn't want to go play outside anymore.

The worst thing was that the *leidsters* completely ignored the fact that he didn't understand a word of what they were saying. They just kept talking to him without trying to explain by gesture what they meant. His frustration with not understanding the other children and the *leidsters* was so big that he completely stopped talking and interacting with people at daycare.

I remember picking him up from daycare one day. His face was swollen and red. He had been crying for three hours because he was so desperate. Nobody had considered calling me.

After this initial experience, we found another Dutch daycare that had more experience with multilingual children. Our son quickly settled in, and a few weeks later he started to sing songs and tell rhymes in Dutch. During our bike rides home from daycare, we would sing aloud the

songs he learned at school. In the beginning he missed a few lines, so I asked the *leidsters* for help. They sometimes sang the song for me, together with some children, so that I could learn the melody and a few more words. They also provided me with the printed lyrics and some hints about where to find other resources to practice at home. Learning the songs and the repetition of the rhymes helped me to improve my vocabulary and to understand simple syntactic structures.

Reading books is another great way to approach a new language, and the advantage of children's books is that the sentences and the vocabulary are pretty simple. We read all the books for children we could find in the local library. We sang the songs my son learned at daycare and practiced the rhymes. Our resources were mostly Dutch children's books and songs. We also went to visit the *Sprookjes Bos* in *Efteling*, an adventure park, in order to learn the typical Dutch stories for children.

The weekly papers were also a big help for me as I learned the names of the brands, and of the different vegetables and fruits. I read the local newspapers and step-by-step, understood more and more. I also listened to local radio stations like Radio West or Radio FM 92 for news from The Hague. On TV, I started to watch the Belgian channel Canvas, when I learnt that Flemish Dutch was easier to understand because they pronounce the word endings, but I also followed discussions on the Dutch channels. I surrounded myself with the language, taking what I called Dutch-word-showers through TV, radio, on the street and in the shops, exactly as my mother did in the sixties when she came to Italy.

A few months after arriving, I discovered that I was pregnant with twins, so I dived into the vocabulary related to giving birth and the Dutch health care system. I also took antenatal classes. Later, I joined a Dutch-French women's club, took stained glass and yoga lessons in Dutch, and even ended up working for a Dutch research institute for a while. Now, I'm fluent in both speaking and writing.

Speaking the local language and getting in touch with the locals is the only way for expats to fully embrace the life in the host country. In my case, it not only helped me to integrate quickly, but also allowed my son and my daughters (who were born in Delft) to experience the same.

I know that expats often don't consider Dutch an important or prestigious language to learn, but I think that every language is valuable, especially if you live in the country and plan to stay for several years. One of the most important reasons for me to learn Dutch is to make my children feel at home in this country. I had already learned several dialects in my life, and even some languages that no one speaks anymore, like Latin, Old French and Old Provencal, so it was out of the question that I would miss the chance to learn Dutch, a language that I really enjoy speaking.

Ute Limacher-Riebold is a writer, coach, language trainer, speaker, multilingual expat-since-birth and mother. She holds a PhD in French and a MA in Italian Literature and Linguistics, both from the University of Zurich. She speaks, reads, and writes fluent German, Italian, French, English and Dutch and has taught Romance linguistics, literature and writing on the university level. She and her husband raise their family of three children in the Netherlands. She writes on her blogs:
Expat Since Birth, Anglo Info and Ute's Expat Lounge.

How good is your Dutch?
Olga Mecking
The European Mama

Like many other expats, I didn't speak Dutch when I first came here. I did, however, speak German, which made a huge difference. German is very similar to Dutch, and they used to be the same language until they parted ways in what is now known as the second sound shift. But I don't want to annoy you, nor do I want to bore the hell out of you. I just wanted to tell you how my Dutch came to happen.

The fact that I knew German, and obviously English as well, allowed me already to read in Dutch before I even took any classes. Real classes didn't really happen until my daughter was seven months old and started daycare. Before that, I attended a 10-week course that focused on speaking, but I had to attend it with my child. As you may know, this doesn't really help you to learn a language. I did, however managed to learn something, met some more people, and made friends. That was good enough for me at that time.

Soon I knew that it was not enough, far from it. I needed more. I needed a real teacher with a real book. I needed a real class. More specifically, I needed something that I could do by myself, without my child. That's exactly what I got when I signed up for Dutch classes at my husband's workplace.

It was just what I wanted: an awesome teacher, highly motivated classmates, and a good textbook. No wonder that I stayed in that class for two years until I reached the highest level and couldn't go any further. But it was enough. My Dutch was fluent. I could go shopping and run errands, and when I got pregnant the second time, I even talked to the midwife in Dutch.

Life was good. I could communicate. I could go wherever I wanted, buy whatever I wanted and get done whatever I wanted to get done. I felt so powerful, using a language that was not my own, and it made people do things for me.

I think I knew how good my Dutch was when I started noticing the subtle differences between Flemish and Dutch. Dutch, with its throaty G

and silent endings, sounded harder than the slightly softer Flemish.

Then the Dutch stopped speaking English with me. They tried German first, because they claimed I had a German accent, but soon realized that my determination to speak Dutch was much stronger than their efforts to make my life—and probably their lives, too—easier. Of course, I told them that I am not German, but Polish. There's a difference, you know.

"Your Dutch is so good" was a compliment I heard a lot. Everybody was extremely patient with me. I was the foreigner who made an effort to speak Dutch, who was working hard to become one of the Dutch people. I was to be praised and applauded.

My children, however, were a whole different story.

If anybody asked me what's the most annoying sentence anybody has ever said to me, I'd have to answer: "Your kids should speak more Dutch." Not only is it annoying because it is not true, but somehow, it sounds very musical and now I have it in my head, forever. "Your kids should speak more Dutch. Your kids should speak more Dutch."

Maybe I should make a recording out of it, with multiple harmonies, and instrumental layers. Then I could play it to anybody who ever wanted to say that to me again. I probably won't do it because I am not mean, just sleep-deprived. Anyway, with a baby, a toddler and a pre-schooler, I certainly don't have the time to do it right now.

Any parent raising multilingual children in the Netherlands has heard this phrase. "Your kids should speak like us! Why don't they?" People can't seem to understand that while children can learn multiple languages perfectly, their vocabulary in each language doesn't develop the same way as the speech of monolingual children.

My older daughter was slow to speak. I had to beg her for every new word. I had to repeat stupid words a million times in a row until I felt like poking my eye out with a blunt object. I had to listen to everybody telling me that she didn't talk enough, and especially, she didn't speak enough Dutch. On top of that, her speech wasn't very clear, and for a long time I was the only person who could understand her. Of course, everybody was convinced it was because she was learning to speak Polish, German and Dutch (oh, my!), and that I should consider exposing her to more of the latter.

I had a short time of utter frustration in which I wondered what to do. Dropping a language didn't feel right, and certainly wasn't an option. I considered speech therapy for her, but decided against it. I knew that if the therapist wasn't entirely supportive, I would give up.

It is already difficult enough to balance out all the languages in our family. I was under a lot of pressure to make it work. I was putting myself under a lot of stress as well in order to make her speak Polish, because I knew it was the language with the least importance in Dutch society, and is therefore the most endangered. My husband didn't worry as much because his expectations were much lower than mine. It was enough for him that the children speak German, and I wanted them to speak academic Polish. While there were other things to keep my mind occupied, I felt as if I had reached an impasse.

Somehow, slowly, she started talking. She added more and more words to her vocabulary, in all three languages. Her speech still wasn't clear, but at least there was progress. At three years old, something happened. A little miracle. her speech exploded.

Suddenly, out of nowhere, there were full sentences, in both German and Polish. On top of that, instead of just choosing her favourite language of the day, she switched between Polish and German without any problems.

At daycare she started speaking Dutch. In full sentences, no less. And she talked All. The. Time. I breathed a sigh of relief. I was off the hook!

Or so I thought. It just so happens that I had another daughter—and of course, she didn't speak enough Dutch either! Her speech and language development were totally normal, so this time, when I heard the "she should speak more Dutch", I just laughed. When she got bigger, I actually heard the opposite: "You know how much she talks? It's *niet normaal*."

While *niet normaal* is one of the most favourite Dutch expressions, it's not a positive one. I however know for a fact that in the case of my daughter, the nannies at daycare used it with pride. It meant her Dutch was more than average. I knew they were very happy with her language development and so was I, because her Polish and German were just as good, and all her languages are getting better every day.

My baby boy is just one year old. To my great surprise, his first word wasn't mama. It was *tata*, Polish for dad. I also swear I could hear him saying his sisters' names. He also enjoys repeating everything I say. His language skills are fine, I think. Just to be on the safe side, I am mentally preparing myself for the next: "He should speak more Dutch" episode. This time I won't mind because I got used to hearing it, but the idea of making that recording is still very tempting.

I thought it quite curious why the Dutch have such differing expectations for my children and me. I was surprised that while my Dutch isn't perfect, I was still applauded for my efforts. This, however, didn't apply to the children. And then I knew. I was the foreigner. My children,

however, were considered locals, and thus the language bar was raised much higher for them.

While this realization was a little disconcerting for a while, I really don't mind now. After all, while I'll always be a foreigner, an outsider, I am feeling more at home here in the Netherlands than anywhere else.

My children are considered a part of the community. They look the part, too, with their blonde (or in one case, strawberry blonde) hair and blue (or in one case grey-green) eyes.

But they will also be something else, something more, and will hopefully retain their ties to all their cultures. Their Dutch of course, is much better than mine will ever be. Their Dutch serves their purpose, and mine serves mine.

So, how good is our Dutch? It's good enough.

Olga Mecking is a Polish woman living in the Netherlands with her German husband and three trilingual children. She is a translator, blogger and writer. She blogs at The European Mama, a blog about her life abroad, raising children and travelling. She also is a regular contributor to World Moms Blog, BLUNTmoms and Multicultural Kid Blogs. Her writings have been published on Scary Mommy, Mamalode and The Huffington Post. When not blogging or thinking about blogging, she can be found reading books, drinking tea or cooking.

Lost in translation
Donna Stovall Bardsley

Bardsleyland

After three years attending a local public school in Amsterdam, my children are now fluent in Dutch, and happily run around with their school friends having entire conversations that I can't understand. Recently, my daughter told me that she now thinks in Dutch instead of English. My sons often slip into Dutch while playing and don't even realize it.

I struggle along, never having made much progress, and my husband has never had the time to learn. I guess we're one of those bilingual/ monolingual families, or part-bilingual families, or I'm not sure what. In other words, our kids speak Dutch, and we try not to embarrass them too much.

My son invited a friend over after school one day, and as we all rode home on our bikes, they talked in Dutch the whole time. Though I understood very little of it, I did hear my son say something about America and English, and then his friend replied something about President Obama and Benjamin Franklin. Then my son started talking about the atomic bomb, to which his friend repeated the thing about Obama and Benjamin Franklin. I'm not even sure if they understood what they were saying.

Not understanding your children's conversations can be problematic. For my youngest son's fifth birthday, we took him and his two closest friends to a popular indoor play place on the outskirts of Amsterdam. Without a car, we had to take public transportation to get there. On the metro platform, while trying to corral three rowdy and hyper five year-old boys, two of which I had no way of communicating with, it occurred to me that maybe I hadn't fully thought the situation through. Once on the metro, as I watched the boys point and laugh at an older man sitting across from them, I was horrified that I had no idea what they were saying, though I could guess that it was not a compliment. The boys probably spent that entire ride talking loudly about farts and poop, while the other passengers inwardly judged my overly permissive parenting.

I've now made sure to add potty words to my small Dutch repertoire, which is appropriate because my Dutch is right about at a two year-old's level. It often feels like my communication ability is stuck at the equivalent of "me thirsty," "mine," and "you're a poopyhead."

In a last-ditch effort to learn the language, I started watching a lot of Dutch children's television. I don't know how much it helped my Dutch progress, but I made big strides with learning to share. My kids are really pleased.

To get by, I rely heavily on Google Translate. It's an imperfect solution, as the syntax and idioms don't always translate well. Which, of course, can also be hilarious. Just this morning I got an email from a parent in my child's class, who, according to Google Translate, is a Mrs. Windbag.

This is from a review I read of a bike shop:

"I can always walk so the bicycles here are quite susceptible to female beauty; tip for the ladies so!"

This was a description of a Groupon vacation offer:

"Routine begins as a welcome rhythm of rest and regularity, but degenerates into an unguarded moment in a chubby syrup dripping from the bank, on television and through frosted mandatory family visits."

It's almost poetic.

My favourite, though, is a translation from a school website:

"Do you not live in the school area? Well, for that you can shoot yourself!"

Talk about harsh.

We speak English at home, as our kids absolutely hate when we try to speak Dutch, but there are some Dutch words and phrases that we've adopted into our everyday conversations. My favourite is *"ja hoor,"* which means "Yes, of course!" and is pronounced exactly like "yah whore." My husband and I use it so much, I'm terrified that I will slip and say it to someone when we move back to the United States. I imagine saying it to the principal at the kid's new school, or the cashier at the grocery store, and I pre-emptively cringe at the awkwardness of it.

Speaking of awkward, that word does not exist in Dutch. This is really

unfortunate because it perfectly describes most of my experiences here, especially the ones where strangers make an offhand remark to me in Dutch, and I respond with an overly enthusiastic nod that I hope communicates, "I agree with everything you've just said, and since you said it so well, I have no need to verbally comment!" Then I chuckle and look away, hoping that they didn't just ask me a question, or tell me about the sudden death of their mother.

In the last month, I've been yelled at by strangers three times. I find it is much easier to be yelled at in a language you don't speak. As they shake their fists at me and spew out angry Dutch words, I shrug and happily walk away, oblivious to anything they are saying. Sometimes it's better to not understand.

Donna Bardsley moved to the Netherlands from Seattle in 2011, with her husband and three children. Though she doesn't regret placing her children in a Dutch school, she would rather not relive that first year over again, ever. Her favourite thing about Amsterdam is biking, and her least favourite thing is headwind. Most days she has absolutely no idea what she is doing, and blogs about it at Bardsleyland. She has a very real relationship with Google Translate.

How to do your laundry in Dutch
Aislinn Callahan Brandt
Life in Dutch

One of the biggest purchases made to date in my adult life was my very own washing machine. Exciting? No, not terribly, but I was making my first large appliance purchase less than a month after arriving as an expat in the Netherlands and my family was already starting from scratch in several ways.

As the first few weeks pressed on, I realized that even some of the most routine tasks had to be done a bit differently than what I was used to in the United States. I was re-learning how to do things around the house, including my laundry. Suddenly, the washing machine we were renting had a problem, and it made more sense for us to buy a replacement that could come with us if we moved.

The purchasing process was interesting for several reasons. I found out early into my search that European washing machines are different from the North American ones, even with familiar brand names. They generally have a slightly smaller load size; the wash cycles run longer due to heating water internally, rather than pulling hot water from a heating tank; spin cycles are more important, since many European households do not use dryers; and the efficiency of the machine is arguably more important due to a higher cost of utilities. Throw in the fact that at the time I couldn't read any Dutch, and my so-called informed shopping experience became an adventure.

After some comparison shopping in a store that I knew offered delivery, the choice came down to two machines. In truth, I only had a general idea of what the differences would be in the long run. The cheaper machine had a larger load size but a lower energy rating and spin speed, and the more expensive machine had a smaller load size but a better energy rating and spin speed. I knew nothing about either brand, so I asked the helpful sales assistant about quality. Naturally, he recommended the more expensive machine, noting that the store receives poor ratings in reviews about the cheaper one just to help me along in my decision. I decided to spring for the more expensive

machine, which also happened to be out of stock for the next two weeks.

The catch was that I needed the machine right away as there was no machine in the house and no laundromat that I knew of within a reasonable cycling distance. Seeing my difficulty, the kind sales associate let me know that for just a few euros more, he could give me a different brand at a reduced rate and have it delivered the next day. If that wasn't enough to seal the deal, the machine had the larger load size, the super-duper-fast spin cycle, the A+ energy rating, and the best ratings of any machine in the Netherlands. He closed the deal and I walked out of the store as the proud owner of a Dutch washing machine.

The machine was delivered and installed as promised the next day, and I was ready to take it for a spin when I realized that this was a Dutch washing machine. And I didn't yet know Dutch.

So, should you ever find yourself in the Netherlands with a Dutch washing machine and little knowledge of the language, here are my helpful hints for getting your laundry done in Dutch.

1. Sort your laundry.

Everyone already does this, but sorting becomes more of an art with the smaller load size. I run a load for white clothes, a load for black clothes and a separate load for towels. For colours, I divide the warm colours from the cool colours. I have no idea if this will matter in the long run for care quality, but at least it keeps colours in the loads from clashing.

2. Add your load to the machine.

Simple enough, right? Just make sure you're not overdoing it. If you need a battering ram to get everything in, you should consider making your loads a little smaller.

3. Determine your settings.

Take a look at the settings listed on the washing machine. You will likely find that your options are available in Dutch and possibly French. Realize that you can't read Dutch, your high-school French didn't prepare you for dealing with a washing machine and, if you grew up in the United States, you still don't know how the centigrade temperature scale works. Because it's different from any other machine you've ever looked at, you probably won't find the symbols intuitive, either.

4. Find the manual.

Congratulate yourself again on choosing a machine with a good energy efficiency rating. Open the manual. Realize that while the other machines you considered in the store included English instructions within the manual, this machine does not, as the manufacturer expects to sell to Dutch, Belgian, and German consumers. Refer to step 3 for your comfort level of written Dutch and French. Consider the introductory German class in your last year of high school also useless for this particular household task.

5. Fire up Google Translate.

This means, you, your laptop, the manual and the washing machine are all going to get real cosy together in the bathroom. Type entire paragraphs from the manual into Google Translate and watch out for typos in your Dutch as that can really confuse both Google and yourself. Alternatively, the Google Translate mobile app will allow you to take pictures of the manual and translate but expect to have to edit the Dutch text found by the software. Patiently translate, or expect to blindly pick out your settings on the machine.

6. Add your detergent and softener.

In the United States, you'll find general detergent for anything you might use in 1,000 scent/colour/dye-free options and a handful of colour-specific detergents, but the Dutch seem pretty big on using colour-based detergent and liquid softener (again, no dryers). Since my son was quite young I've always included some sort of oxy-cleaner to the wash. To get the ingredients into the machine, you need to translate even more terms. The *voorwas* (oxy-cleaner) means pre-wash and requires an additional setting on the machine. *Wasmiddel* is your regular detergent, and *verzachter* is your fabric softener. Each will require a different compartment. Refer back to the manual/Google Translate to determine which one is which.

7. Press the Start button.

And pray. At least the Start button is easy to find. It's usually the biggest one on the machine. Expect a two-hour wash cycle. Add or subtract time for particular wash cycle features you may have added or removed.

8. Examine your wash.

You probably didn't mess it up any worse than any other time in your laundering history, but it's still good to have a peek and decide if you need to change your approach to the next load.

9. Hang dry.

Every Dutch household owns some sort of elaborate drying rack that may actually be a Transformer. You can do yourself a favour by going the extra step and buying clothespins in advance to help spread things out and dry them faster.

10. Repeat as needed.

Which is always more often than anyone wishes.

Having the machine in your own home is an improvement over the alternative. With a little practice, you too can do your laundry in Dutch.

Aislinn Callahan-Brandt, also known as Ace, started life as an expat in the city of Tilburg in the Netherlands in the summer of 2012 with her husband, son, and two cats. Originally from the United States, she blogs at Life in Dutch *to share her experiences as an expat, traveller, parent, and whatever else is on her mind. When she isn't blogging or planning the next travel adventure, she's working on learning the Dutch language, teaching English, reading up on history, crocheting or making a mess in the kitchen.*

Misunderstood
Catina Tanner
Amsterdam Mama

Sometimes, being able to speak another language can get you in trouble. For example, I once told a homeless man to die. Bless his heart, he was standing in front of the supermarket trying to sell a homeless society newspaper to make enough money to sleep in the local shelter, and I told him to die.

As I walked out of the supermarket he said "Hi," and I responded with a big friendly grin on my face, in my slow southern accent "Die". This probably sounded more like "Dyyyye."

Of course, I didn't mean to tell the guy to drop dead. What I meant to say was either "Dag" (the Dutch equivalent of hello or goodbye) or "Hi," which was what I normally say in English. Instead, he got one of my brain-dead-Mama Denglish (Dutch-English) combos: "Die."

It wasn't until a few seconds later that I realized what I had said. No! What an idiot I was, how could I get so confused? Then again I had just put pure coconut oil on my hair thinking it was conditioner, so obviously the elevator was not going all the way up.

I stopped walking away and I thought maybe I should go back and explain to him what I was trying to say. What would I say to him, "Hello mister, I am a sleep-deprived bilingual mother and I never know what language to speak because I only have two brain cells left after giving birth."?

I felt terrible, but I decided it was best to keep walking. I hoped that he didn't hear me or that the blinding warmth of my smile made him temporarily deaf to my faux pas. I hoped that if he did indeed hear me that he wouldn't remember me the next time I walked through the supermarket door. I felt rotten all the way home, but as soon as I walked into my door, the kiddie chaos forced it out of my memory.

Until I went to the supermarket the next day and there he was standing at his usual spot. My heart raced when I saw him, but surely he saw hundreds of people a day, so how could he remember what each person said to him? I sucked it up and began my walk of shame into the

supermarket. I was brave. I looked him in the eyes and said "Hi."

He glared back and turned his head. He remembered. And he snubbed me! He snubbed me the way I often saw others snubbing him. I felt terrible.

As I walked around filling up my shopping basket, feeling low, I thought to myself, I was just misunderstood. I could fix it. I had to face the problem and solve it.

On my way out of the door I took a deep breath and walked over to him. I touched his arm gently and looked deep into his eyes. I gave him a slow wink and the word "Hi" rolled off my tongue like a bowling ball getting ready to go into the gutter.

With a surprised look he said, "Hi". That was when I saw a smile spread across his face and his eyes began to sparkle. I'm forgiven. Finally, I was no longer misunderstood. From now on I would to stick to the language I knew best, Flirt. Every culture speaks that language.

Catina Tanner was born and raised in the southern US but for the past 13 years has called Amsterdam her home. She is a communications professional for an international criminal court though her most treasured title is mom to her two half-Dutch children. She blogs about her experiences as an expat mother at <u>Amsterdam Mama</u>. You can also find an article or two on the web she has written in between bouts of sleep deprivation. Her two dreams in life are to become a writer, and to someday have children who sleep through the night.

V

Working

Finding my authenticity in the Dutch workplace
Katherine Strous
Naturally Global

It has been seven years now since I moved to the Netherlands. When I moved, I was freshly married, in my mid-twenties, and knew almost nothing about Dutch culture. My main source of input was my Dutch husband, but after eight years of living in Asia, he was not a very reliable resource. I was young and eager to live in a new country, so when the opportunity to move for my husband's job came, we jumped at the chance. I figured I would be able to figure out the culture and find work once we were in the country. I have never been one for a lot of preparation. We filled a few suitcases and we were ready to start a whole new life.

Luckily, through a little networking, I soon landed a job at one of the largest Dutch companies in the Netherlands. As I was signing the contract, the human resources manager asked me if it had always been my dream to work for this company. I was totally flabbergasted. Up until a few months before, I had never really heard of the company, but I didn't think that would be a nice thing to say so I just nodded and weakly said yes. She looked up at me critically and I knew I was in trouble. My wishy-washy answer was definitely not appreciated, and that would be a lesson I would have to keep learning.

The first months on the job were hard. My colleagues seemed nice, but I didn't know how to connect with them. Conversations were often stilted, and suddenly without much notice, they would abruptly end the conversation and leave the room. I always felt a little insulted when this happened, and in fact, still do, though eventually I learned not to take it personally.

Meetings were even more challenging. I would often leave them so angry and rant later to my husband, "They won't let me finish my sentences. They are so rude! I can barely get a word in the conversation." My husband looked at me with sympathy and said simply, "You have to interrupt too, and force your way in."

84

I already knew this, but I had no idea HOW to do it. From a young age, I had been firmly taught never to interrupt because it is rude and it means you are not respecting the other person. It made me wonder what Dutch parents were teaching their children. Was interrupting encouraged in Dutch households? It would take a few years before I had my own half-Dutch children and finally learned the answer to this question.

My biggest dilemma at work was that I also knew that my manager did not perceive me as very capable because I was so quiet. Even worse, I sometimes had the feeling that he didn't trust me because I never voiced my opinions strongly. After living for six years in China, a culture so vastly different than my own, I had become a more quiet and observant person. These are qualities that were very important in China, where people are not so forthcoming with their opinions.

But it was very clear that the Dutch do not appreciate quiet people in the workplace, as this is often interpreted as being weak or untrustworthy. My great skills at observing and watching body language were of no use here because the Dutch just say exactly what they think. Suddenly, these skills that had taken me so much effort to develop in China were worthless in my new environment in the Netherlands.

So here I was, in a company that had hired me because of my specialization in intercultural relations, and I couldn't even solve my own intercultural difficulties. In my field, there is always a lot of discussion about which competencies and skills make you effective across cultures. Many consultants and experts believe that if you master a certain set of competencies, then you will magically be effective in dealing with new cultures.

The problem with that approach is that each one of us is different, with different strengths and different talents, and it is just not possible that everyone would be able to master the same set of competencies and/or skills. This approach also forces us to focus on our weaknesses, what we are not good at, rather than our strengths, the outcome being that we will just be mediocre and likely inauthentic.

I decided my best course of action was to be authentic and to find a way that would fit with my strengths and use them to demonstrate that I was capable at my job. I will never be like a Dutch person. I was raised in a totally different culture with completely different values and

perspectives on how I understand this world. I would need to find MY way of being successful in this new environment.

Now, seven years later, still happily at the same company, I don't think a single one of my colleagues would any longer perceive me as being weak, incapable or dishonest. I still take very different strategies to approaching people and solving problems, but I manage in a way that makes sense in this culture. I even see that my colleagues also learn from this and see that there can be a different way of doing things. I know sometimes they disapprove of my approach as they very much value being straightforward and transparent, but sometimes I find it helps to hold back opinions in order to move forward on issues.

Though I am still not and never will be Dutch, I can very much hold my own in meetings. I still don't feel comfortable interrupting people, though sometimes I will do it if I really need to. Instead, I have found a way to be firm and clear while still keeping true to my soft and quiet side. These days, I often get compliments from colleagues that I am able to bring up ideas in a way that is kind but still firm. I have also accepted that it is not always appreciated but I am okay with that, because I know this is the way that works best for me.

My advice to other people trying to navigate the Dutch workplace is to be authentic and to connect to people with that authenticity. Being authentic does not mean that you don't adapt, but rather that you adapt in a way that makes sense for you. It took me a long time to understand my strengths and how I can leverage them effectively to connect to other people. It is an on-going process, but I find that self-awareness is essential when trying to work in cultures so different than my own. It is not about being like the Dutch, but about connecting to them as my real self.

Katherine Strous is a native Californian who has spent the last 15 years living abroad from Chile to China to the Netherlands with a number of places in between. She now lives near Haarlem with her three young children and very understanding Dutch husband. You can follow some of her adventures in creating a natural healthy lifestyle as an expat and a parent at her website, Naturally Global.

The tax man
Molly Quell
Neamhspleachas

"You are likely to be audited," my accountant informed me.

I was flummoxed. "Audited? For what?"

"Well, it is not possible for you to work so many hours," she replied.

Ahh, the old "not possible." Any foreigner who has even passed through the Netherlands on their way to sunnier destinations has probably encountered a "not possible." It doesn't mean it's not possible in the way that raising a zombie hoard from the dead is not possible, it's more along the lines of "I don't feel like doing it" or "We don't believe you."

The latter was the "not possible" I was given.

I didn't make enough money last year to actually pay income tax on, but Belastingsdiesnt (the Dutch tax office) simply cannot comprehend the notion that someone might work more than 40 hours per week and not take a vacation during any given calendar year.

Small business owners in the Netherlands are divided into two camps. Those who work for their own companies part time and those who work full time. The previous year, I indicated that I had worked full time at my little consulting company, as well as working at a few temporary jobs.

Any small business owner will tell you that you don't make very much money your first year. As it turns out, I like money, so I'd supplemented my meager company income with a few part-time gigs.

And now the tax office wanted to punish me for it.

"You're sure," she asked, "that you worked at least 1,225 hours last year on your company?"

That's because 1,225 is the magic number that designates you are a full-time employee of your business.

If you do the math, you'll discover that 1,225 hours actually means 24 hours of work per week for 52 weeks per year, or working 40 hours per week for only 30 weeks. Twenty-two weeks of vacation a year seems excessive, even for the Dutch.

I patiently explained to my accountant that I had worked all of the hours I indicated and I had an extensive spreadsheet to back me up. In fact, she had been the one to tell me that the Dutch tax office requires just such a spreadsheet. Fortunately, not only was I a workaholic, I was also a tad obsessive-compulsive. Thus, documenting every hour I spent working for my company wasn't much of a stretch.

I handed her the spreadsheet, which indicated I'd worked 2,187 hours during the year for my company. That's 42 hours per week with no vacation.

She reviewed it extensively and then punched some numbers into her desk calculator. She looked up at me.

"This would mean you would have worked about 40 hours per week at your company."

"Forty-two. But I'm not counting." I replied.

She frowned, pulled another sheet from a folder on her desk labelled with my name and consulted it, then entered a few more numbers into her desk calculator.

"And with your other work, you worked 70 hours a week?"

"Yes," I replied. I knew I was working 70 hours a week. So did my partner, my dog, and my sleep debt.

"All year."

"Yes."

"And you could not have taken any vacation."

"That's correct."

"Well, I don't see how that's possible."

Now I wait for my little blue envelope.

Molly Quell works as an editor and online marketing consultant and spends her free time listening to NPR while baking cookies and drinking beer. Originally from the United States, sort of, she blogs irregularly at Neamhspleachas but contributes to a variety of publications. You can see more about her professional work at www.mollyquell.com.

Being a SAHM in the Netherlands
Farrah Ritter
The Three Under

I worked several jobs before finally reaching my goal of becoming a high school English teacher. I taught for a few years, had my first son and fully intended to go back to work after we had our second and they both were in school. Well, life's pretty funny when you make plans. We ended up being surprised when we found out that we were expecting twins instead of just our second, and within two years we moved overseas to the Netherlands.

When my teaching certificate lapsed, I lost the will and desire to throw myself into a career and instead poured everything I had into the boys. Let me tell you, having three little boys under two, then three, is a full-time job. So I don't feel bad about not working outside of the home. I do plenty of work inside and I love my job.

In the United States, I had no issues being a stay at home mom, or SAHM, nor did anyone else I knew. Besides, it didn't bother me what anyone else thought and I doubt my status even crossed their minds. Many of my friends probably just hoped I was surviving having three babies in the house.

Then we decided to move to the Netherlands. My oldest being three and my twins just freshly turned two, it was without a doubt that I would remain home and my main job would be getting them to and from school each day. Now, of course, I laugh because being a SAHM here is a challenge indeed.

You'll find that people want to know what you do or when you're going back to work. It doesn't seem to be the prestige of having a job only that the Dutch like to know that you're contributing. I have given up explaining that I taught high school until I had my first son and that I plan to go back to work someday when they're all in school full time. The Dutch don't care. You will see their eyes glaze over. They just want to know how you are contributing and where. It's nothing personal, though, it truly isn't. So, when people ask if you work, make up an arbitrary date as to when you will return to an imaginary career that you

may have someday.

The Dutch have their connections already, so don't expect to make friends. It's just a cultural difference, nothing personal. I exist on the periphery of the moms at school. They are all very friendly, and I have made one good friend. Kids make their own playdates at school, it is not necessary for you to cultivate a relationship with the parent. They set it up and ask (tell) you when you can come to pick them up or if they can play with another child. I admit I have sent my four year-old to homes where I didn't know the name of the schoolmate or parent, with only their house number and street in the notes section of my iPhone. The Dutch are sort of known for establishing their social circles early in life, and they are not really keen on adding outsiders.

If you worry about the language barrier, don't. I use my child as a translator. Yes, I really do. My four year-old's Dutch has gotten so good that if need be, I trot him out and he does the work for me. I have also asked him to translate while out shopping when necessary.

"Where are the mittens?" never sounded so complicated. So many people in the Netherlands will speak English that it will help you ease into the life much, much quicker than if you were moving to Germany, for example.

Some chores are easier than others. For example, once I figured out which foods were which, I was able to sign up for grocery delivery. This has made my life so much easier. Sure, you can go to the nearby market or grocery store… but why would you? You can order everything you need online and have it delivered straight into your kitchen, for a very low price, sometimes even for free. These days, my biggest complaint is that I have to put stuff in the fridge. Back home, I never enjoyed spending my Saturday afternoon grocery shopping.

There's the whole health aspect to consider as well. Meat, vegetables, breads and a lot of food will usually expire quickly, because they're of better quality and don't have the preservatives they'd have back in the United States.

Laundry, unfortunately, is harder. You will never be on top of your laundry ever again. Feel like you're a slave to laundry now? Maybe this will be liberating. The washer will be smaller and if you have a dryer,

it will not dry things completely. Everything is backed up and you will soon start asking yourself "Just how many times is wearing this before washing it appropriate?" That is, if you're lucky enough to have a laundry room at all, as living spaces will be small. We went from huge side-by-side appliances to stackables and a small table. Being in the Netherlands is all about smaller spaces, and you need to adjust.

Shopping for home goods is going to be different. Long gone are the days at Target, but there is a store called Hema. It's not the same, not even close, but it will have to do. Just don't expect to have an easy time developing photos through their web store, and there is no such thing as a super cart that will seat up to four children. Costco is a thing of the past too, but there's nowhere to put all of that stuff anyhow!

You've traded in your main mode of transportation. You can pat yourself on the back for riding a bike instead of driving a minivan. You're saving yourself gym or yoga fees while taking your children to school. Just expect it to rain on a daily basis, and when it doesn't, you should be thrilled. You will become very adept at riding a bike while holding an umbrella.

Become well-versed with technology and you have all the social media interaction you could want, albeit in the afternoon with the time zone difference. And all of the television shows from home. The internet is a beautiful thing. It's not that strange, really, when you consider that TV shows in the Netherlands are in English with Dutch subtitles.

Overall, a bonus of being a SAHM in the Netherlands is that people back home will think you're amazingly brave for taking this leap into the unknown. It's a crutch and a feeling of empowerment all at the same time. We love it here, and just extended our stay for three more years. The Netherlands has been very good to us and we're very thankful for that.

Farrah Ritter is fumbling her way through Europe as US expat in the Netherlands. Her three boys love the Dutch life so much their family extended their first contract of two years to an additional three. Their small village of Oisterwijk has proven to be a wonderful place for their family of five to live. She blogs their European travels, adventures, and

mishaps of Dutch living at <u>The Three Under</u>.

VI

Making Friends

Making friends
Molly Quell

Neamhspleachas

Moving abroad is bad for your social life.

You lose all of your friends. No one, not even your best friend or closest relative, is getting on a plane to have a beer with you after work or help you move a sofa. You will have no one.

Finding new friends is a challenge. If you moved for work, your social circle is your colleagues. If, like me, you moved for your partner's work, your social circle is their colleagues. I only knew engineers for the first twelve months I lived in the Netherlands. You don't have anything in common with these people, other than a paycheck originating from the same bank account.

Even if you do have things in common, do you really want to be friends with your colleagues? After all, you already see them eight hours a day.

Outside of work, you have to make new friends from a much smaller pool of potential friends. Interacting with the locals, whatever country you are in, is hard. That means that you're limited to the international community. Internationals are always a smaller subset of the general population, so even the statistics work against you. Subdivide that into people your age and actually have something in common with and the pickings are slim.

Also, you have to figure out where to actually meet these people. Social groups, parenting groups, networking groups? Perhaps you've moved to a place where you have plenty of options. While all that selection seems positive, actually attending all of these groups is exhausting. If you're working or you have kids or just want some alone time with your spouse, getting out there and meeting people takes time, effort and money. It's like dating, but without the sex.

My social life was a train wreck. I got really caught up on TV when I first moved.

It's taken about three years, but I've finally settled into some real friendships. I met some non-engineers. Some good people. People who

I will remain friends with after I leave, or they leave, or we both leave. People who will help me move that sofa or grab that beer at the end of the day.

It can take a while. First, you have to pass the international community smell test. Namely, everyone else wants to figure out how long you're going to be here for before they commit to making friends with you. Some people simply aren't willing to invest emotionally in another person unless they get a minimum three-year commitment.

As an aside, I simply do not understand this. The worst-case scenario is that you get an awesome friend somewhere else in the world who will put you up when you come to visit and give you the local's tour. In the best case that person stays where they are and you have a friend there. There is literally no downside.

Then, they decide to accept you. It takes you a few months to realize you have nothing in common with these people, except that you both speak English and you collectively hate various aspects of the local culture. While you're eternally grateful to not be re-watching every season of *The Wire* again, you find yourself making excuses to avoid the dinner parties of these friends because, fundamentally, you aren't really friends.

That's not to say that they are bad people. They aren't. You just aren't meant to be.

Now it's time to go through this process of shedding all of those people from your life (and their stupid dinner parties you didn't want to go to anyway) in favour of people who you actually want to be friends, because now you've come into contact with enough people to have met people you actually want to be friends with.

Think about your circle of friends. Your close friends are people you've come into contact with over a period of time. Primary school, university, jobs, sports teams, study abroad. You cannot possibly replicate that in a few years. That's a lifetime of friendship achievement.

Of course, once you meet people you do truly like, you have to go through the whole process of actually becoming friends with them. Like admitting embarrassing things about your past. Confessing to your weird quirks. Seeing each other in your pyjamas.

You will find those people. The ones whose dinner parties are fun, whose interests align with yours. Who will help you move that sofa, and grab that beer.

It is possible. I know because I've been there and found my tribe. And now I'm really behind on TV.

Molly Quell works as an editor and online marketing consultant and spends her free time listening to NPR while baking cookies and drinking beer. Originally from the United States, sort of, she blogs irregularly at <u>Neamhspleachas</u> *but contributes to a variety of publications. You can see more about her professional work at* <u>www.mollyquell.com</u>.

Friendships are like wine

Amanda van Mulligen

Expat Life With A Double Buggy

With a glass of red wine in my hand, I contemplate the good friends I left behind in England. They were among the many things I couldn't parcel up and take with me on my journey to a new life. We travelled through our teenage years together and a few of us had even spent our primary school years together. My best friend married a man I had grown up with, shared secrets with and been through thick and thin with. It was a wrench to leave these friendships behind, to inevitably confine their depth to the past.

I said my farewells to them on the eve of leaving on a ferry to the Netherlands. We spent the evening reminiscing about the past and speculating about the future, sitting huddled and cramped together around a wooden table in a local pub, getting pints in, like British friends do.

I already knew as I waved goodbye from my Watford flat doorstep that they were irreplaceable, and that I'd miss them every day for a long time to come. I only came to realise just how much I'd miss them after a few months of being on Dutch soil. It hit hard one day that making friends with the locals wasn't going to be easy. Making new friends abroad wasn't going to just happen.

First, language was an issue. My Dutch was pitiful back then, 14 years ago. I could say the basics, but an in-depth discussion on current affairs, culture or politics? Not even close. Most Dutch people speak English, but I was starkly reminded that for them it is a second language. Why should they hang round with me having stilted, difficult conversations when they could have easy conversations in their mother tongue with people they had known for years?

Second, although the physical distance between my birth country and my new homeland is not all that far, culturally they are different. Finding things in common needs work. The conversations my Dutch partner had with his friends left me treading water; I had no idea about the films, music or events they talked about. They had grown up in

a different world to me. They laughed about different things. They shared different memories. It was hard to scratch below the surface of acquaintanceship. I needed to find my own tribe.

So where do you go to meet Dutch people looking to make friends with a British girl who'd just arrived on a boat? You don't walk into a Friends Shop and pick up some locals to replace the life-long friends you left behind.

I'm an introvert. I don't like putting myself out on display to the world. I prefer my own quiet corner. Not a frame of mind conducive to making friends - not abroad, not anywhere. I had friends, good friends, and I hadn't imagined that my future self would need to find new ones. It was a daunting reality.

I discovered just how hard making new friends in your twenties and thirties is. I'm guessing it would be hard anywhere, not just in a foreign country. The simple act of meeting people doesn't guarantee a friendship; meeting people is merely the first step of many. Friendships take time, lots of effort and patience. It's a hit and miss process.

When I first moved overseas, the search for friends took second place to finding a job, finding a place to live, the bureaucracy of the immigration service, learning how Dutch life works, learning where I could find things. In short, learning to live again took priority. Once I settled I went in search of a social circle. I started with expats. People like me.

I went for drinks with an expat group. It was a disaster. I spent an evening in a bar watching the conversation of a group of women like it was a tennis match. Stories told by one woman after another, each tale more depressing and discouraging than the last, the dissatisfaction of expat life oozing from their pores. They all seemed to wish they were somewhere else, and at that moment I knew that feeling all too well. I had never before felt so alone in the company of people. These expats weren't like me.

I tried another expat group, a few years later. It was a mother and toddler group, but the turnover of faces was high. These mothers were in the Netherlands temporarily. They were passing time here. They weren't stopping long enough to learn Dutch, integrate and go local. I didn't fit. These expats weren't like me either.

Meanwhile, I met people at work. I got to know my Dutch neighbours. I met Dutch parents dropping my children off at the *peuterspeelzaal* and school. I started to follow the interests I once had, back before I had to start living life from scratch. One day, I realised my social world had expanded. Nods of heads and smiles had turned into hellos, which had turned into brief conversations, which had turned into invitations for coffee and cake, which had turned into the start of a friendship.

Friendships had been growing around me whilst I wasn't looking, whilst I was getting on with life.

No, making friends when you move overseas is not easy. Making friends with locals is not a guaranteed part of expat life. Not all expats are destined to be friends. A common language doesn't make a friendship. I learnt that when you stop searching and start living normal life, friendship has a habit of creeping up on you.

It turns out friendship is like a good bottle of wine. The soil is tested and the vines are planted, the fruit grows and ripens and is plucked at just the right time. The goodness is squished out of the grapes, complementing ingredients are thrown into the mix, and the juice is fermented, barrelled. When the moment is right, the wine is bottled. It's ready.

That wine goes through a process. It takes time. It takes work. It takes patience and you can't rush it. But the result is a perfect bottle, a wine that you can savour.

As you pour your next glass of wine, think of the work, the time, and the effort that has gone into making it. Savour it. Give a thought to the bottles that lay on your wine rack before this one, bottles that didn't pass the taste test, which ended up as cooking wine or drain cleaner. It makes that bottle you hold in your hand all the more pleasurable. The same is true of friendships. Good friends are worth waiting for.

Amanda van Mulligen is a freelance writer. You can see her work at amandavanmulligen.com. British born, she was whisked off to the Netherlands on a promise of a windmill wedding and now raises three sons with her Dutch husband. She writes about expat life and all things parenting on her blog Expat Life with a Double Buggy as well as on the

topic of highly sensitive children at <u>Happy Sensitive Kids</u>.

The leech
Nerissa Muijs
Adventures In Integration

One of the greatest aspects of being an expat, especially if you're from the antipodes, is that you have a regular influx of guests from home visiting and replenishing your Tim Tam and Vegemite supply.

Loved ones on their world trip of a lifetime will detour to spend a couple of days with you or even park for months. Some of these visitors are more welcome than others and we have certainly had our share of wonderful houseguests, but right now I must introduce you to The Leech.

There was this guy I went to university with but didn't really know very well. We weren't friends and didn't hang out together at all. We reconnected via Facebook when I found a group dedicated to the rugby club I played for (yes, I was the hooker) and we commented on one another's posts from time to time.

When he announced he was doing a world tour and would be in Amsterdam, I suggested we get together for a drink. I had thought about offering him a place to stay but we didn't know each other well and my husband didn't know him at all. In my family, it's common to hear from strangers who have been sent on from an aunt or a cousin but I decided it wasn't fair to my husband and kept it casual. After all, I hadn't seen this guy in more than 10 years. I wasn't even sure I'd even be able to pick him out in a crowd.

About a week before he was due to arrive in Amsterdam, I got a message. His passport had been stolen and the cost of replacing it had wiped out the rest of his travel budget. He was devastated to say that he wouldn't be coming. At this point my love for strays and underdogs kicked in. I invited him to come and crash with us for a couple of days on his way through to catch his flight home from wherever it was.

The day he was due to arrive we had been at a music festival for the weekend in Germany. However, because I knew he was coming, we packed up early and made the five-hour dash home to make sure we would be back with plenty of time before he arrived. He was catching

the bus from Brussels, and we knew to expect him by about 17:00 or so. 17:00 came and went. So did 18:00, 19:00 and 20:00. My husband did a lap of the neighbourhood to see if he was wandering around lost (Almere Haven can be a bit of a warren if you weren't born and raised here), but no sign of him. He started to get a bit shouty because I didn't have a number for him and he only had mine, and we hadn't heard a word.

By 22:00, we agreed that he wasn't going to show up. We were exhausted. At 23:00, we decided to go to bed, only to hear the doorbell and there he was. Turns out that the bus had been delayed, but he didn't think to let us know. I didn't press the matter and nor did he apologise for putting us out but my husband was already spitting and stomping and wanting to kick him out. But I wouldn't let him say a word, because the guy was a guest. You can't say anything to a guest, right?

My husband said his good nights and I stayed up, politely making conversation and thinking to myself "I don't remember this guy at all! Not even a little bit! Have we even met?" I asked him how long he would be staying; because I was due to have surgery that week, politely hinting that a short stay would be appreciated. I was horrified to hear "Oh, I think I'll stay until Saturday or Sunday."

"What?! A couple of days had all of a sudden morphed into a week! Shit." I thought.

The next day, we sent him into Amsterdam for a look around and asked him to let us know if he would be home for dinner or not, so we could plan for him. I loaned him a fully loaded public transport card so he could easily get around, explaining how he could top it up at machines or ask for help at the information counters.

My husband decided that even though he was still pissed off from the night before, the nice thing to do for our house guest would be to take him to the local pancake boat and treat him to a cool, typical Dutch dinner. 17:00 came and went with no word. So did 18:00, then 19:00. At 19:30, we decided we weren't going to wait any longer and left to go have dinner without him.

Upon arriving home at around 21:30, we found him, comfy on the couch, with an empty stomach as he had been expecting to join us.

I, with my stupid guilt and need to please, leapt up, cycled to the supermarket and prepared a meal for him while my husband stomped upstairs before he choked the guy

I hadn't been feeling the best, as I was nervous about the surgery that was coming up, and realised that my period was late. Before going to bed, I took a pregnancy test and holy shit I was pregnant! We looked at the stick in total disbelief, but instead of jumping up and down from joy, terror and amazement, we had to whisper in our own bedroom as we couldn't share the news. There was no way that we were going to share the best news of our lives with a guy we hardly knew. There was so much to do, to talk about, and to enjoy but we felt trapped, all because there was a now very much unwanted houseguest in our spare room.

Meanwhile, he had yet to book tickets to wherever it was he was going on to, and was having problems with his Australian credit card. Of course, they were problems that could only be resolved by calling Australia. On our phone. At our expense. Because he was too cheap to activate international roaming on his mobile.

When he finally managed to sort out his money problems, he booked a flight for the Saturday. Thank God, only three more days with him. Turns out he booked his flight for the wrong month! My husband was now really angry with me because even though I was upset, stressed out and feeling like a door mat, I still wouldn't allow him to have words with the guy about it (in case we had to bury a body somewhere).

On Thursday, I sent him to The Hague. I bought his ticket for him, assumed he would not be home for dinner (he was) and sent him on his way. Naively, I expected that he would pay me back for the ticket, and for the fully cashed-up public transport card I loaned him, but no, of course not.

By the time Saturday finally rolled around, we were ready to kill him. So far he'd had his hand out, been fed, had a free place to sleep, been offered endless bottles of beer and had all the internet and telephone access a person could possibly ever want. We hadn't seen a thing in return. He hadn't offered to cook dinner or offered to tidy up a bit. He had just emptied our fridge, used all our toilet paper and just made a general nuisance of himself.

My poor husband. Each time there was a new incident he would say, "That's it! I'm getting him out of here!" But I wouldn't let him say anything. He was getting more and more wound up. At a time when we should have been joyous, we were stressed and angry with one another. Oh, and exhausted. The minute you find out you're pregnant you immediately become a world champion sleeper

We took The Leech to the train station so he could catch his connection; only to find out he had no cash whatsoever to buy a train ticket.

Nothing. So I had to pay for that as well. My husband was refusing.

After all, he'd kept the man in beer and burgers for a week. He shook our hands, said thanks, and stepped on the train, never to be seen or heard from again. And thank God for that.

We've learned our lesson. Close friends and family only. And we tell them the story of The Leech to put the fear of God into them before their luggage has even wheeled to a stop.

Nerissa Muijs had big plans. She was going to see a few castles in England before going home to continue her dream career as a tour guide along the west coast of Australia before retiring with too many cats. Then something happened. A boy derailed all of the carefully laid plans and pulled her to the Netherlands before popping the question and getting her up the duff in rather quick succession. She is obsessed with crochet and can't stop talking about it at Miss Neriss. Nerissa spent years as blogger writing about integrating in the Netherlands and the dreaded inburgering exams at Adventures in Integration. Nerissa is also a mum of a precocious yet adorable little girl and desperately wants a dog. But her husband won't get one.

VII

Marrying a Dutchie

My beautiful Dutch wedding
Amanda van Mulligen
Expat Life With a Double Buggy

At my wedding, my father-in-law said, that, in essence, the ritual of finding a partner has remained largely unchanged throughout history. The one thing that has dramatically altered in recent years is the size of the talent pool.

A couple of hundred years ago, the pool to choose mates from was limited to the local village, or at a stretch, a neighbouring one. The flirting took place around the village well or in the hay barn. These days the village we have access to has expanded. The whole world has become our mating ground. We now flirt in online chat rooms and with the help of webcams. That's how I ended up with a Dutch husband.

That said, the Dutch seem to care a little less than some other nationalities about the institution of marriage. It's not uncommon to start a family and get married if the mood grabs you after your brood is well-established. In our case, our first-born was six months old when we decided to say *"ja"*. But the decision to get married was made a year before, on the fourth of July 2006 to be precise, when I was three months pregnant.

James Blunt was singing 'You're Beautiful" on stage at the Westergasfabriek in Amsterdam. The sun was shining on a perfect summer's afternoon and we were as carefree as we could be. When my Dutch partner asked me to marry him, I didn't need to think about it.

We told our families. My British family rained verbal congratulations down on us. My Dutch family kissed any cheek they could find in a fit of *felicitations*. Then my father-in-law to-be encapsulated the Dutch attitude to marriage by playfully saying "You know you don't have to get married because you're pregnant right?"

Funnily enough, on hearing the news we were expecting a baby a British uncle said, "I assume they are getting married then."

In any case, we followed our own hearts and minds, the order would be first a baby, then a wedding. But planning a wedding when many of the guests live in another country was potential headache fodder.

The first issue we faced was location, location, location. My British family is extensive, my father being one of 12 siblings. The Dutch side of the wedding party was modest in comparison, yet the idea of marrying in England held no attraction for us. It was no longer my home. Besides, when I left England in 2000, I had promised my mum I would marry in a windmill.

So the search for a picturesque, typical Dutch setting commenced and was quickly found in Hauwert, 45 minutes northeast of Amsterdam. It wasn't quite a windmill, but we were content with the stunning watermill that was in perfect keeping with the thatched roofs, timber ceilings, cosy fireplaces and an exquisite outside courtyard.

Our next big decision was the guest list. After lots of difficult conversations, our choice was to keep the wedding party small. We could not have known then that the wedding party would end up smaller than we wanted – a hard lesson that not everything in life can be planned.

As the summer approached and our wedding day loomed, we busied ourselves with our son and making the last of the arrangements for our big day. But it wasn't all plain sailing.

The beautician that had come for a try-out before the wedding day was suddenly unavailable and had to be replaced. A new try-out took place and the minor setback was quickly recovered. Months later I saw the replaced beautician on a Dutch TV show, tearfully sharing her tragic story with Char Margolis, the psychic. A family death had been the reason for her quick exit from our wedding day.

Something that wasn't so easy to fix was a falling out with my mother. The ins and outs are less important than the result, which was that she would not be coming to our wedding. And that was final.

For health reasons, my grandparents' attendance was not a sure bet either. Furthermore, we had more than one divorced elephant in the room and we had doubts about how divorced parents and their partners coming together in one room would pan out. To top it all off, during the entire month of June we saw nothing but rain. As we crept into July it didn't look like it would stop.

There were times when planning a wedding as an expat felt lonely.

Making my own wedding arrangements in the absence of not just my mother, but also my best friend, was hard to swallow at times. Finding the perfect wedding dress was not the occasion I had thought it would be. My best friend wasn't there to give her opinion over a glass or two of wine like you see in the movies and my mum wasn't there to wrinkle up her nose at a dress that made me look like a sack of potatoes. It was hard for any of my close family or friends to get involved in wedding preparations in another country.

All the setbacks, as they arose, felt like they could be showstoppers.

But they weren't, because of why we were getting married and because of what our wedding meant. For us, it wasn't just an expensive party where everyone got to dress up in nice clothes and hats and have a mini break with windmills and tulips as a backdrop. It was our way of standing up and telling those close to us that we had made the right choice, that I had made the right choice to move countries, that our instincts and our hearts were right - that we belong together.

There were doubters when I jumped across the North Sea to join my Dutch partner after only nine months of knowing each other. An aunt had taken me aside and asked me if I was sure I knew what I was doing. I told her I was. She asked how I knew. I just did.

Our wedding day was a way to shout out that sometimes you have to take a risk. You have to jump into the unknown because what is waiting on the other side is too good to throw away.

The day itself kept to the script. My grandparents made the trip over, the divorced parties unilaterally declared a ceasefire and the weather gods smiled down on us so we could say our wedding vows outside in the sunshine.

Our beautiful, chubby six month-old son as a pageboy at our beautiful Dutch wedding was the icing on the cake. We got married for him too and for the siblings we hoped then that he'd have. We got married because it felt like the perfect way of completing the first chapter of our story together. The story of how a British girl met a Dutch boy, moved to the Netherlands, started a family and then got married.

Amanda van Mulligen is a freelance writer. You can see her work at amandavanmulligen.com. British born, she was whisked off to the

Netherlands on a promise of a windmill wedding and now raises three sons with her Dutch husband. She writes about expat life and all things parenting on her blog <u>Expat Life with a Double Buggy</u>, as well as on the topic of highly sensitive children at <u>Happy Sensitive Kids</u>.

Being in love with a Dutch man
Julia Modi
Social Fusion Amsterdam

Being a foreigner in the Netherlands is all about intercultural experiences. How you manage to blend in, reeducate yourself and become more knowledgeable, open and non-judgmental. This process takes place slowly, and sometimes painfully, as you do your best to understand things that are foreign to you. It starts with understanding those who are closest to you. As I am in the Netherlands for my husband, this process started with him.

Since I was 10 years old, I knew I was not made for my country. I always felt pressured there, not being able to fully express myself. I have never liked the system, the bureaucracy or the sense of people judging me all the time. I admit I knew I could never have a Romanian husband because of their way of thinking and acting, always asking something of you. When I really had enough of everything and everybody, I entered a Yahoo! Chat and was extremely lucky to find my husband. I started talking to him. At that time, it did not cross my mind to marry him, not even to get to see him, but after talking every day we developed feelings for each other and decided to meet. Just through chatting, he amazed me with his freethinking and constant moral support.

After one year of communicating online, we met and had one great week in Amsterdam. After only three days, I knew he was the one for me. It was written on his forehead, just for me to see. I could not believe it. Going back to my country was horrible, so after a few months I moved into his very small room at the student house.

Getting to know each other better was not always very easy. I was astonished to see that he really cared about his time with his best friends, whereas I felt completely excluded. As an Eastern European, that was difficult to understand for me. Luckily, it did not happen often. Every Monday he would come home at 1:00 and never wanted to tell me what he was doing. Again my culture kicked in, and I started imagining the strangest things possible. Eastern Europeans interpret

everything. We always think there is more than you say and that most of the time you are lying if something seems a bit strange.

I thought was he was going to a strip club! Yes, it is hilarious now, but then it was painful. I decided to talk to him and found out that he was seeing his best friend who did not agree with our relationship. They were playing badminton. He felt too ashamed to tell me about his friend and their games. As I love badminton, he thought I'd want to join.

What do you encounter as an Eastern European with a Dutch partner? His friends may not agree with his decision. In their opinion, you are with him just for the money or papers.

Most of the time, his family thinks the same.

I started the long process of trying to change the mentality of his friends and of his family. After almost nine years of being together I feel tolerated, but nothing more.

Because of his family and friends, he also had to keep many things about us secret. I still cannot understand this, as I am used to telling my parents and my best friends everything. We moved to The Hague, but none of his best friends knew and neither did his family. After four years together, we decided to start a family, to get married and to move back to Amsterdam. We did all these things, but not without obstacles. We encountered a lot of judgment along the way.

In the Netherlands, you can see many couples, some with children, living together in harmony for many years, without any thoughts of getting married. I truly appreciate this possibility, but for me, it wasn't the right path.

The truth is that he wanted that as well. However, his mother could not understand this. How can you get married after only four years of being together? She was very surprised when we told her, but she was happy that we did not have a date. Just a week after that incident, I found out I was pregnant so we had to meet her again. She was astonished. You can imagine what she was thinking. We did not get any help with the wedding, and I also did not see any happiness on her face. I felt sorry for my husband.

After we had our child, my mother-in-law came to see him, two hours after we returned home from the hospital. She said, "What a nice piece

of meat!" which, as you can imagine, is just what you want to hear after twenty-seven hours of labour in two different hospitals. She now loves her grandchild, she is always happy to see him. She has even started to like me and I do not feel that resentment anymore. She even admitted once, "You are a great team," referring to my husband and me.

Even though there were obstacles, life was great together. It still is. From the beginning, I loved the fact that he could cook. He showed me a few recipes and I got to know Asian food because of him. He takes equal part in doing house chores.

You hardly see this in Romania, where a woman may be criticised for forgetting to clean a window. Many times he has to tell me that I don't have to clean, or cook so much if I am tired or busy. He says I don't have to stress, he can do it, or we'll do that when we have the time.

Dutch fathers get fully involved in their children's lives. Before having our boy, I realized that my husband was great with children. Once, he played very nicely with a boy that I was babysitting. The child loved him. As a father, he takes our son to the playground, to the swimming pool and to school. My husband got fully involved with raising our kid, from changing diapers to preparing his milk and feeding him, from making sure I had enough sleep to playing football together and reading books.

What else can you expect when you are married to a Dutch man? You can expect to see his feelings. You will see him crying, laughing and sharing his happiness with you. When I told my husband that I wanted to visit my parents and take our son with me, he just started crying. He couldn't take time off from work, so he had to stay in the Netherlands. But he could not bear the thought of not joining us. In the end, we didn't visit my parents and decided to wait till summer.

You can also expect your Dutch partner to see things differently from you. You should not think it's wrong. It's just another way of seeing things, of solving problems. I was always amazed by the fact that he had a different approach, until I understood that it was fine and not wrong.

I know that my learning process and adaptation didn't stop here, but now it enters yet another phase. My son is entering the Dutch education system soon. My husband has to be the one who pulls my brakes again

and opens my eyes to the new possibilities this change will bring.

Iulia Modi is 36 years old and lives in Amsterdam together with her husband and son. She is originally from Romania. She is a very active job seeker and a blogger. She loves spending time with her family. Her background is in education and she sometimes teaches groups of bilingual kids while she is also planning to launch her own business in teaching and language coaching. She also blogs over at [Social Fusion Amsterdam](#).

Could you please just lie to me?
Katherine Strous
Naturally Global

I am married to a lovely, kind, sweet and caring man. He is a fantastic father and a dedicated husband who puts up with me on my most difficult days with the utmost patience. His love for me has always been constant and unwavering. The moment I met him I knew there was something special about him, because he allowed me to mock him endlessly about his lack of knowledge of the essential food group known as Pop-Tarts. I knew right then and there that he was the one for me.

My husband is also Dutch, which is why he didn't know about Pop-Tarts and probably why he allowed me to mock him. The Dutch like to laugh at themselves. He also carries the typical Dutch traits of brutal honesty and mind-numbing pragmatism. This, combined with my fanciful optimism, developed from growing up in the United States and an anything-is-possible attitude makes conversations at times, shall we say… difficult. For example, here's a conversation that took place many years ago.

"Why can't we run the 100km sunset to sunrise ultra-marathon in Mongolia? We have six months to train for it!" I exclaimed in my most reasonable voice to my infinitely calm husband.

He then looked at me carefully and proceeded to explain in painstaking detail why exactly this was not a good idea. My counterargument was not so rational. I believe there were a lot of curse words in there. You can imagine how the rest of that conversation went.

I knew that on a logical level he was right, which didn't help with managing my anger. So what if we had never run more than 42.5 kilometres? So what if the racecourse was in the middle of the night in treacherous mountains in a country we had never been to? So what if there was not nearly enough time to train? I knew it was a crazy idea that any reasonable person would not even consider. It also sounded exciting, extraordinary and fun. For me, it didn't even matter if we really did the race, it would just be fun to fantasize, discuss and maybe

even find a more reasonable adventure. But the moment he criticized my idea, it killed any desire in me for fanciful daydreaming.

My husband couldn't understand why I was angry because it was also his perspective that we were just discussing the idea. It drove me crazy that his first reaction was to assess how realistic it was and, in my mind, criticize it. I wanted to discuss the possibilities, not the difficulties. At the time, neither of us could vocalize our different perspectives because we couldn't understand how the other was thinking. We were completely foreign to one another.

After the Mongolian Incident, as it is now known in our house, I thought about why we clashed so heavily in these kinds of conversations. My 23-year-old self came to the very profound and brilliant solution that he just needs to lie to me. To me, it seemed like the perfect answer. In the US, we are often taught the so-called sandwich feedback method, in which you sandwich a negative comment between two positive comments. It helps to soften criticism and negative feedback. I thought teaching him this approach would help us in these kinds of conversations.

The next day over dinner, I burst out my little epiphany to my husband. He looked at me, astonished. He couldn't believe that I was asking him to lie. I didn't realize it, but I had just stumbled on a bigger cultural issue then the one that had caused the previous fight. At the time, he listened to my very rational explanation that it wasn't really lying, but just softening his responses. I explained that in the US this is known as a white lie. I believe I even drew a diagram of the sandwich feedback method. My husband appreciates detail. Even after all my passionate explanations and diagrams, he still didn't look convinced, but he decided to play along and agreed to try it. Did I mention that my husband loves me?

What I didn't know at the time is that honesty is one of the core values of the Dutch. It is where the directness that they are infamous for comes from. They highly value transparency and truthfulness. In addition, they do not take discussions or confrontations about ideas personally. My husband couldn't understand why I was so emotional about the subject. He didn't even see his criticisms as hurtful because he was just discussing the idea, and that had nothing to do with me as a person. He

would even see it as an insult to me if he had to lie. This for him would do more damage to our relationship then being honest.

Like many people from the US, I am more personally and emotionally attached to my ideas. It is hard for me to see the person as separate from the idea the way the Dutch do. We, therefore, are also concerned about the feelings of the person and maintaining a good relationship when discussing ideas. Honesty is also important to us, but the feelings of the person are sometimes even more important. Hence we have developed the concept of white lies or lies that don't do any harm. On the contrary, for many Dutch any lie is considered harmful.

Therefore, my husband could not really understand why I would take his criticisms so personally, and I couldn't understand why he wasn't protecting my feelings. He definitely couldn't understand why I wanted to be lied to. Consequently, he never did lie to me. I guess that is something most wives would be happy about.

In the end my brilliant idea was an utter, dismal failure. The old saying that "You can't change a person, you can only change your attitude" rings true for me as I reflect back on that time. My husband has never lied to me to protect my feelings and I have never stopped coming home with outrageous ideas. While this still leads to some good fights, it also makes us a good team. We have had amazing adventures together because I dare to propose them and because my husband makes them possible.

My mother always said to me that she and my father, who are still married after 35 years, stopped fighting after about 13 years of marriage. Her explanation was that they finally just accepted the other person and let go of the things they couldn't change. We are not at 13 years yet, but we are getting close. While we still have some pretty good fights, as the years pass, I see us increasingly accepting what we can't change in each other. We also start to value those qualities that caused so much frustration in the beginning as part of the person we love.

I love that my husband is Dutch and that he grew up with the values he did, because he forces me to think about the way I see the world and helps me become me a better person for it. In my experience relationships across cultures can be difficult, but if you work through the

rough spots they can also be pretty amazing.

Katherine Strous is a native Californian who has spent the last 15 years living abroad from Chile to China to the Netherlands with a number of places in between. She now lives near Haarlem with her three young children and very understanding Dutch husband. You can follow some of her adventures in creating a natural healthy lifestyle as an expat and a parent at her website, Naturally Global.

VIII

Giving Birth the Dutch Way

Stuff Dutch People Like No. 15: Natural birth
Colleen Geske
Stuff Dutch People Like

There is no denying that Dutch people like to do things the natural way, the "real" way and the "normal" way. In fact, I would say the majority of them are downright obsessed with making sure the behaviour of others follows some unwritten rules of normalcy and realness. So it should come as no surprise that this preoccupation with keeping it real extends to all acts, birth being no exception.

Now readers, I can see you scratching your heads and asking how I am qualified to make such remarks about birth in the Lowlands. I am proud to say that although I haven't been busy writing, I have been busy making and birthing a beautiful being which, I might add, is no small feat. Yes, for you readers who affectionately refer to me as "dude" or "that funny guy from Stuff Dutch People Like," I hate to disappoint, but I suspect my intimate knowledge of birthing will finally convince you of my femininity.

The good news is that I am back and my 3-month bundle of joy (milk, spit, gas and poop included) is only slightly annoyed that I am ignoring her. She grunts and squeals as I type this. But, back to the subject at hand, natural births.

Eight years ago I looked across a plate of *bitterballen* in a smoky Dutch brown cafe and I told my then-boyfriend that "Yes, I'd be happy to live here," but that "No, I would never ever (repeat ever) give birth in this country." I suppose the expression "never say never" has its merits.

I just couldn't get by head around the Dutch you-must-birth-in-your-bathtub-at-home-while-burning-sage attitude. My first *huisarts* (general practitioner) seemed to be obsessed with the notion: babbling on about her upcoming delivery and how she would be in her own home, with candles and her favourite music, and just couldn't wait to be able to be all drug-free, naked and *gezellig*. My early twenties, slightly judgmental North American self could only muster the thought: "Oh Christ, is she part of some Dutch hippy commune?! Time for a new doctor!"

After moving neighbourhoods (and changing doctors), I realised that

she was (most likely) not part of a commune but just shared the average Dutch opinion that birth is not a medical condition and as such, did not require medical interventions (or facilities). My new doctor also shared this opinion.

Dutchies are the pioneers of the modern-day home birth. Although numbers have decreased over time (and continue to decrease), a hefty 25% of all births in the Netherlands are done at home, with another sizable percentage of women attempting to do so. Compare this to less than 2% in France, Belgium, Germany and the United Kingdom and you can see why this is indeed a very Dutch thing.

Birthing in the comforts (hah!) of home also implies doing so sans body-numbing and mind-altering substances. Is that a gasp I hear from my American readers? Yes, Dutch women and their childbearing hips are notorious for drug-free births. Even in the hospital, only 6% of Dutch women have an epidural. Across the Atlantic, things seem to be precisely the opposite. A recent study found that only 6% of women in large hospitals in the US opted for drug-free births.

While pregnant, I had a lot of time to ponder the why of this situation. Were Dutch women genetically superior? Did they just not feel the pain like the rest of us? Had all that bread, cheese and drop gone to their heads? Were they seriously just tougher? Was it all their free time to prepare? And what precisely were they trying to prove anyways?

After speaking to a fair many, I realized the truth was they just weren't all that scared or bothered by it the pain, and rationally accepted it to be a natural part of the package. The very direct Dutch folder given to me by my midwife summed up the attitude best: "Giving birth hurts. Pain is a normal part of birth, so expect it."

Fast forward eight years, and you will find me (equipped with a fabulous doula, super competent midwives, and a supportive hubby) sitting in a hypno-birthing class in the middle of Amsterdam, determined to have a natural, drug-free birth à la Dutch, but also realizing that sheer determination sometimes isn't enough. Of course, I couldn't quite follow through all the way and give birth at home. Sorry folks, I suppose I'll never be that Dutch. I did follow through on the natural part, and I will say it was one of my proudest moments and

biggest accomplishments*, one I don't think I would have come by if it weren't for the Dutchies and their obsession with the normal.

*Pregnancy and birth in any shape, size or form is a kick-ass accomplishment, no matter how or where you birth!

This post originally appeared on Stuff Dutch People Like and has been reprinted with the author's permission.

Colleen Geske is the best-selling author of the popular blog and book <u>Stuff Dutch People Like</u>. *She is originally from Winnipeg, Canada and has lived in Europe since 2004. When not busy writing, Colleen spends her days as a communications and social media consultant. Colleen holds a Bachelor of Commerce (Honours) degree in International Business and Marketing from the University of Manitoba. She currently lives in Amsterdam with her family.*

My double joy experience
Ute Limacher- Riebold
Expat Since Birth

When we came to the Netherlands in 2005, our son was two-and-a-half years old. We were really enjoying our first summer in the Lowlands, biking, making new friends and spending lots of time on the beach.

In September 2005, I discovered that I was pregnant. Even if it was not a planned pregnancy, we were all very happy and looking forward to welcoming another member to our family. My son was excited that his biggest dream would come true.

One afternoon, when he came home from the *crèche* (daycare), he told me out of the blue: "There are two babies in your tummy." We had never talked about this possibility, and it still seems creepy to me that my son already knew something in advance that I and my husband would only find out at our first screening appointment a week later. I was already 38 years old. Like in most European countries, a pregnancy after the age 35 is considered at risk and is followed by a gynaecologist, no matter how well the former pregnancies went.

During this appointment my gynaecologist showed me several blurry images on the screen, switched it off, turned to me and asked me: "Did you see everything?" Of course, I was familiar with these kinds of pictures. I saw a body, arms, legs and a beating heart.

He asked again, "Did you see everything?" That was the moment I noticed his big smile and he added, "You're expecting twins!" Thanks to my predictive son, I was already calm. When I turned to him, he smiled and said, "I told you so."

My husband and I still recall this scene with all its details. I remember the smell of the room, my son's smile and the face of the gynaecologist when I told him what my son had foretold a week earlier.

What followed were weeks of planning and intensive work, because I wanted to finish several projects I had started before we moved to the Netherlands. I signed up for prenatal classes in order to learn all the vocabulary and taught everything to my husband in the evenings. I learned all about Dutch healthcare and was very thankful for the help

I got from my general practitioner, the nurses and other Dutch mums from my son's *crèche*.

I also read all I could find about twin pregnancies, and thus knew all the risks. I'm just the kind of person who likes to know about what is happening in order to be prepared if anything should go wrong.

The other participants in our prenatal class gave me valuable tips too. I knew that I was entitled to a *blije doos* and a *kraampaket* (a "happy box" containing many items for the birth, for new mums and the newborn) from Etos, Kruidvat and Prénatal, and that I had the right to other services because I was pregnant with twins.

Even though I had a double risk pregnancy (because of my age and the twins) and some invasive measures were offered to me, I decided not to get any of them and opted for a genetic ultrasound. It was a unique experience to observe my two babies for almost an hour (yes, it took that long!) and to chat with the two nurses who were visibly enjoying this show.

Thanks to my first pregnancy, I knew exactly what kind of exams are due in which period and I was pleased to see that in the Netherlands they did more or less the same tests as in Italy, where my son was born. I received more ultrasound scans because of the twin pregnancy and when I wanted to have more, just to be reassured, the doctors in the diagnostic centrum were always cooperative. They took great care of me. I always had a list of very precise questions to ask every time I visited and got all the information I wanted. I think this is something many expats need to learn. If you are proactive, you will always get help.

I appointed a *kraamverzorgster* (maternity care nurse), requesting one that had experience with twins. I also chose a special hospital where I could stay as long as I wanted, because I wouldn't have wanted to leave my newborns in the hospital alone.

During the whole pregnancy, my gynaecologist and the nurses gave me precious advice about how to reduce stress and get enough vitamins and they always asked how my son and the rest of the family were coping with this situation.

When I was 35 weeks pregnant, my gynaecologist congratulated me for

being among the very few mums of twins who would deliver after week 35. When I was 39 weeks pregnant, he told me that I was the first mum of twins he knew who would keep the babies longer than 39 weeks.

In the last three weeks, I was asked to come in for screening every three to four days. Since week 36 one of my babies was in the right position, so I was quite sure I could consider a natural birth. When my girls finally decided to be born, I was 41.5 weeks pregnant. My contractions started after dinner. I put my son to bed and told him that our babysitter would come and take care of him, and bring him to us in the morning. He just said, "Mum, everything will be fine."

After our babysitter came, we checked in at the hospital. This was all much easier and quicker than in Italy. I got on a wheelchair, which wasn't possible when I delivered my son, and was brought to a nice room. The nurse was friendly and soon was backed up by another one and another one.

Shortly after my water broke, a gynaecologist came into the room and sat right in front of me. He calmly explained that he was only there to make sure that my babies and I were fine. With some help from the nurses, my first girl was born right after midnight.

My second one was about to follow shortly, but as she wanted to come with hand and foot first, the gynaecologist stepped in and said in a very calm voice, "Now, let's show this little one where the way is." He pressed twice on my belly and after two slight pushes, my second girl was born nine minutes after her sister. I didn't feel anything. I think my endorphins were running high and the birth of my first girl left lots of space for my second one. I felt completely safe and cared for. Without any drugs, I was finally an incredibly happy and proud mum of two healthy girls who weighed around three kilograms each.

I got my double *beschuit met muisjes* (a biscuit sprinkled with anise seeds) that the Dutch traditionally offer to every new mum after birth in the morning, and I shared it with my husband. When my son arrived with the babysitter, he only had eyes for "his girls". He was and still is a very proud big brother. After having fed my babies and a last check up, I was allowed to go home at 11:30.

For the following eight days, I had a fantastic *kraamzorg*, who was a

grandmother and experienced twin nurse. She took care of my girls, my son and me. She didn't only visit me and my twins every day, she also made sure we all ate healthy food, that I drank enough and got enough rest. She made it possible for me to have one-on-one time with my son and taught me how to bathe two little girls without being stressed by the screaming of either one. She gave me such wise advice that I still recall and cherish.

I'm glad I gave birth to my girls in this country, because I know that in other countries I wouldn't have been allowed to take them full term. Doctors would have given me no choice and carried out a C-section at week 35 or 36. Not every country has such great maternity care.

Of course, every pregnancy is different, and every woman is different. Anything can happen at any time. I felt secure during every single phase of my pregnancy, and I'm sure this wouldn't have happened if the system had been different.

Ute Limacher-Riebold is a writer, coach, language trainer, speaker, multilingual expat-since-birth and mother. She holds a PhD in French and a MA in Italian Literature and Linguistics, both from the University of Zurich. She speaks, reads, and writes fluent German, Italian, French, English and Dutch and has taught Romance linguistics, literature and writing on the university level. She and her husband raise their family of three children in the Netherlands. She writes on her blogs: Expat Since Birth, Anglo Info and Ute's Expat Lounge.

The welcome stranger
Amanda van Mulligen
Expat Life with a Double Buggy

She stood on the doorstep with her winter coat over her crisp white uniform, showing just a hint of a lilac collar. Her eyes were smiling. Suddenly, here she was, the stranger I had reluctantly agreed to let into our house during one of the most intense, emotional weeks of our lives. The stranger that was to share the ardour of first time motherhood with me. The stranger that would guide me through the basics of caring for this newborn bundle with a red, scrunched-up face, dressed in a soft baby boy blue jacket sleeping soundly in my arms, oblivious to the sudden impact he had made on us.

Our *kraamverzorgster* (maternity nurse) hung up her thick coat and walked into our living room with purpose and authority. She firmly shook my hand, as I remained perched on the sofa.

"I'm Gerrie," she said as she beamed a big smile at the three of us.

She admired our little son and said cheerily, "*Gefeliciteerd, mama en papa!*"

She then asked me how I was feeling. I told her I felt like I'd been hit by a bus.

"Upstairs to bed then," she stated matter-of-factly, "and we'll get Samuel settled up there too."

Because I was feeling bruised and battered, Gerrie helped me up the stairs one slow step at a time, then painstakingly on to our raised bed. The rest of my first full day as a mother passed in a blur as Gerrie introduced me to the basics of breastfeeding my son, how to make up his Moses basket, take his temperature, powder his naval string, change his nappy and comfort him when he cried inconsolably. She gave us tips for the night and then left us to it.

The next morning, Gerrie let herself into our home with the key we had entrusted her with and came up to check on the three of us. Zombified, my husband and I filled her in on our sleepless night, filled with a newborn's desperate cries and our clueless responses.

She made us breakfast and told us it would get easier. She told us to get some sleep whilst our son slept and cleared up whilst we rested. When my son needed to be fed, she was at my side to help. Whilst I showered, she changed the bed linen, aired the room and vacuumed the floor. By the time I came out of the shower, exhausted from the effort, the bedroom was fresh and clean. I sat up in bed and ate a lunch of open cheese and ham sandwiches and a bowl of fresh fruit.

Then it was time for our son's first bath. All screamed out, he fed and fell soundly asleep and it was naptime for us all. As we slept Gerrie cleaned the bathroom, the baby room, and the kitchen, hung up washing and wrote up the day in our file.

When our little family was awake again, she gave us instructions and tips for our second night alone at home. It all seemed so easy and straightforward in the light of day with the voice of experience talking in our ear as we sat nodding to her instructions. She left.

As night fell, we suddenly felt alone, insecure and unprepared for the challenge of parenthood. I couldn't remember now why I had insisted we only have *kraamzorg* for the minimum hours per day. During my pregnancy, I hadn't been able to envision feeling comfortable with a stranger in my house, especially not during the intimacy of the first week after the birth of our first son. I felt that a maternity nurse would be an invasion on our new family, a spare cog, an unwanted presence. How wrong I was. I hadn't foreseen how comforting it would be to have an experienced maternity nurse with us when we brought our newborn baby home. Within two days, she was a stranger no more.

Over eight days, Gerrie structured our days and slowly but surely imparted words of wisdom to help us care for our baby. She gave us new tips every day to deal with a little person whose only method of communication was incessant crying.

Gerrie also cared for me. She took my temperature daily, checked that my stitches were healing, kept in contact with my midwife to relay any issues, got my energy levels back up with regular fresh, healthy meals and helped ease postnatal aches and pains with regular reminders to take paracetamol, do pelvic floor exercises and drink lots of water.

When the baby blues hit on the third day, she reassured me it was

normal to feel so helpless and tearful. She reminded me every day that motherhood is a learning process and every day that goes by is a day that caring for a newborn gets easier. Soon it would be second nature to recognise his different cries and respond. She built our confidence up and filled our newborn parents' toolbox to the brim. She did her job perfectly. She made herself redundant. Within a week I was up and about, taking back my role in our home, caring for our new family member as if he'd always been around. Thanks to Gerrie, our fledgling family had found its wings.

On the eighth day, she said goodbye to the three of us. My tears ran freely as she mapped out what would happen over the coming days with the midwives and the *consultatiebureau*. She told us we would be fine. She laughingly refused bribes to stay longer but accepted flowers, a birth card and a photo of her with our son in her arms. For her, we were one of many newly formed families she put on the right path. For us, she was a woman we will always remember: a stranger that became a part of our family for eight days, then disappeared without a trace.

Amanda van Mulligen is a freelance writer. You can see her work at amandavanmulligen.com. British born, she was whisked off to the Netherlands on a promise of a windmill wedding and now raises three sons with her Dutch husband. She writes about expat life and all things parenting on her blog Expat Life with a Double Buggy, as well as on the topic of highly sensitive children at Happy Sensitive Kids.

IX

Raising the World's Happiest Kids

Parenting the happiest kids in the world
Rina Mae Acosta
Finding Dutchland

One of my most vivid memories of being an American mother living in the Netherlands was, and still is, the first time I witnessed Dutch children playing football on the streets—unsupervised. We had recently moved into the Dutch suburbs of Utrecht, into one of those neighbourhoods with detached, non-descript houses with huge gardens. For my husband and me, it was more of a psychological experiment.

I was bouncing my baby in my arms, freshly baptised into the world of motherhood. My precocious son, utterly convinced that he was much older than his year old self, wanted nothing more but to toddle after the big kids. Of course, I acquiesced and followed him closely. By default, I became the unofficial babysitter for the whole neighbourhood.

The scenario would repeat itself for the rest of the spring until they left for the next month (or more) to explore the world with their families on their annual summer family vacation. Then they would all come trickling back, adequately sunburned and once again commence with imaginary play. This would continue well into the school year, weather permitting. Non-existent homework for the ten and under crowd gave them the freedom and liberty to get into all sorts of trouble, fun and mischief.

"No wonder," I muttered to myself, "that these are the happiest kids in the world."

As a child who grew up in the San Francisco Bay Area, it would have been inappropriate and irresponsible for parents to allow kids to play outside without any parental supervision. The urban residential streets of Westwood Park, San Francisco were far from safe. Entire childhoods were predominantly locked inside, away from the potential dangers of kidnappers, paedophiles and cars.

What kind of parents was I surrounded by? These kids were left out to their own devices most of the time. No round-the-clock, before- and after-school activities such as piano lessons, ballet classes, after-school

enrichment programmes or soccer practices.

The biggest difference between their approach (the Dutch way) and mine (the American way) was that they were much more "parent-centric" as opposed to "child-centric." Dutch mothers refuse to make child-rearing an all-encompassing, mind-numbing, 24-hour martyr vocation. Time for themselves, whether trying to get their sexy back, socialising with friends, having much needed alone time or going on date nights with their baby daddies, is absolutely essential.

Not surprisingly, Dutch parents automatically enforce the Dutch national pastime of a regular schedule. Thanks to the *consultatiebureau*, the Dutch child healthcare clinic for all children under the age of four, a universally agreed-upon schedule of when Dutch babies eat, play and sleep is generally adhered to. Dutch parents believe that by following a relatively strict schedule, their babies are able to get enough rest to grow. Perhaps this is why Dutch babies grow up to be the giants that they are today.

At the crux of Dutch parenting is a *laissez-faire* attitude towards all things related to baby. At the very heart of this Dutch parenting attitude (and arguably the unofficial Dutch national anthem) is the idealization of simply being normal. *Doe maar gewoon, dat is al gek genoeg* or Just be normal, that's already crazy enough. It is a near-automatic response I get from my Dutch counterparts if I ever dare expose my natural, American neurotic tendencies.

"Your baby has a high fever?"

Doe maar gewoon, hoor.

"Your baby can't walk yet?"

Doe maar gewoon, hoor.

"Your baby can't talk yet?"

Doe maar gewoon, hoor.

How can I just be normal, *hoor*? *Hoor* is an untranslatable Dutch expression encompassing the ambiguous notion of empathy. I'm a first-time, recovering perfectionist mom raised under the tiger mom parenting flag, who really has no clue of what she's gotten herself into. How can you define what falls within the healthy parameters of normal?

Growing up in quite weird circumstances, I don't even know what normal actually means. The Dutch parenting emphasis of being satisfied with striving for average, of mediocrity, grated on my American sensibilities. I, Rina Mae, was never destined to be average. Neither are any of my offspring if I could help it I thought incredulously. No wonder those that followed the beat of their own internal music, like Vincent Van Gogh and Alex van Halen, left. No way were my son and I going to be corralled into the infamous Dutch homogeneity.

Or so I thought.

My mommy intuition, or perhaps more accurately, my feeling as if I was spiralling into a pseudo-mommy depression of being overwhelmed and isolated from the adult world, made me wonder if Dutch moms were actually doing something right. All of my other Dutch mommy friends seemed more relaxed, described their babies as easy, slept through the night, reclaimed their pre-baby physiques and maintained their own social lives.

Maybe I really was doing too much. Regularly having some me time and being able to have long, uninterrupted showers wasn't going to psychologically damage my child. In fact, when I did start investing more time in myself and satisfying my own need to have occasional alone time with my thoughts (I am an introvert and writer after all), he actually seemed fine.

What took me quite a long time to realize and fully comprehend is that the Dutch idea of average was in no way similar to my Americanized preconceived notions.

Average and normal, for the Dutch, is actually set at a much higher standard than in the United States. For the average citizen, the Netherlands ranks higher in terms of almost all facets of modern day life: education, safety, maternity care, health care and overall well being.

When it comes to the division of labour between parents, Dutch moms seem to have it a lot better than their American counterparts. Due to being the part-time work champion of Europe, the Netherlands encourages and respects both parents' right to work reduced hours to better juggle the demands of parenthood. *Papa dag* (or daddy day) is

becoming a more popular option, allowing Dutch fathers to play a more equal role in childrearing.

But it doesn't stop there. Dutch fathers often take equal responsibility for household chores such as cleaning, cooking, laundry and ironing. The infamous Dutch *polder model* which emphasizes the idea that everyone shoulders their own weight begins at home.

In terms of my initial impressions that the Dutch thrived on lazy parenting, I couldn't be any more wrong. While I may not ever be comfortable with my son playing outside unsupervised, I am beginning to understand the importance of childhood and unstructured play. For Dutch parents, childhood is simply magical enough without having to focus too much on creating memories, engaging in carefully orchestrated activities and watching the child's every step. Completely opposite from the modern day equivalent of helicopter parenting, they seem to understand the intrinsic need for their children to explore the world on their own individual terms, to be given the freedom to take risks and learn that actions have consequences.

The closest analogue to Dutch parenting is Calm The Fuck Down (CTFD), coined by daddy blogger and writer David Vienna of The Daddy Complex. Except while Vienna describes the CFTD method as being the latest parenting trend, Dutch parenting is a lifestyle deeply ingrained within the culture. Dutch parents have been parenting this way for generations. Due to their strong cultural pride and identification with their heritage, they will likely continue in this direction for generations to come.

This shouldn't be considered as a clear endorsement of Dutch parenting. Arguably the biggest complaint of foreigners and other Dutch parents is how misbehaved, wild and raucous Dutch children can be. Anyone who's ever gotten into an argument or a disagreement with one of these highly opinionated miniature Dutch people would probably wish that they would come up with better arguments, or at the very least, show a bit more respect for their elders.

What I am a proponent of, however, is to seriously consider what the Dutch parents do so well. They recognise that mothers also have an identity outside of motherhood, that parenting is a joint effort by both

moms and dads and, most importantly, to allow children to simply revel in the marvels of childhood. As a greater society, we're often too consumed with developmental milestones, achievements and unrealistic adult expectations of children's behaviour.

As the Dutch would say, *"Doe maar gewoon, dat is al gek geneog."*

Rina Mae Acosta is a San Francisco Bay Area native and writer currently living in the Netherlands with her Dutch husband and son. She holds a B.S. in Molecular Environmental Biology from the University of California, Berkeley; a M.S. in Health Economics from Erasmus University, Rotterdam; and currently pursuing a PhD (serious street credibility) for living a life well lived, parenting and expatriation. Her blog Finding Dutchland is as an honest attempt to connect and stand strong with other parents and kindred spirits as she navigates the world of being an expat mom.

Dutch daycare to the rescue
Olga Mecking
The European Mama

Mother's Day is nearing, and my daughters just gave me the gifts they made for me: a little jar of homemade applesauce and a nice painting. We hung the painting on our wall and ate the applesauce. It was delicious!

Last month, they did lots of awesome, spring-related activities, such as catching butterfly larvae, watching them turn into butterflies, and then setting the butterflies free. They came home with little bean plants. Before that, they had learned a jungle dance, the names of all the jungle animals and how to recognize their sounds. This is no science class and neither is this an art course. This is regular Dutch daycare.

I smile when I remember all the different activities they do at daycare. Going to a local petting zoo. Picnics in the park. Dance class. Having their hair cut and braided by a hairdresser who comes in every six weeks. Not to mention the fact that my eldest speaks Dutch as well as German and Polish. When I think of all these benefits, I can't believe that I was so nervous when I signed my first child for daycare. Maybe putting things into perspective would help to explain why.

Let me start by saying that Dutch daycares are nowhere near perfect, of course. A carer once told the children not to speak Polish with each other, something I am extremely sensitive about. The food at daycare could have been better, as the children eat Dutch bread (which consists of plastic and air) with some highly processed cheese or ham spread. The latest cuts in subsidies have had negative effects on daycare quality. Employees have been made redundant, and more and more moms have decided to stay at home with their children because they can't afford daycare anymore. But for me and my family, it was a great decision and one that saved my sanity.

I arrived in the Netherlands with a six week-old baby, after a long hard birth I had yet to recover from. I had a thesis to write, a translation project to work on and a baby to care for. Said baby screamed a lot and I had wished I knew what she needed me to do.

Mentally and physically, I was not at all in a good state. Guilt didn't help me any. But I knew one thing. If I was to remain sane, I needed me-time, lots and lots of wonderful me-time. My husband noticed this and the daycare was his idea.

I fought him. I said good moms don't send their children to daycare at only six months. I said that I could do it, totally on my own. Work, write my thesis, care for the baby, maintain a house, and cook. If my friends can do it, so could I.

Deep inside, I knew that he had a point, so we applied to two daycares and got accepted into both of them. When we went to visit the daycare we eventually chose, I was extremely anxious. Luckily, I needn't have worried. The daycare was nice and clean, the carers were kind and the children seemed happy. Then I saw it. The huge, beautiful smile on my daughter's face, and I decided to let go of the guilt. She would be fine.

She would start with two days a week. I was still nursing, and I could come to do it at daycare. With my two days of spare time, I was finally able to start a Dutch language class. A few times a year, the daycare organised walks to the nearest park. This is where I met the woman that would become a very close, good friend. Paradoxically, in a place where I hoped to meet Dutch women, the first woman I started talking to was Turkish. It didn't bother me though. I had friends and that was what mattered. I was learning Dutch. I was working on my thesis. I was finally starting to feel better about myself!

Then I found out I was pregnant again.

I wrote my thesis throughout the pregnancy and graduated a few months before giving birth. We moved to another house, but we didn't send our daughter to another daycare because I was too afraid that she would not be happy with such a change. So, for a few months, I would get her dressed (with difficulty, as it was winter and the snow was heavy), strap her into the stroller (also with difficulty, also because of the snow) and bring her to daycare, which took around 20 minutes. This wasn't fun, I must tell you.

My second child was born in the spring. Again, we walked to daycare, but this time the snow was gone so it was much easier, except that my big girl was nearing two. Instead of heavy snow, I dealt with heavy

temper tantrums. I would have preferred the snow.

When my second daughter was six months old, we enrolled her at the same daycare. Again, the guilt, the letting go of guilt, the going to daycare to nurse, another Dutch course. The cycle repeated itself, except this time, I was writing a blog instead of a thesis, which was much more fun. We also changed the daycare schedule so that they would go every day in the afternoon, which would allow me calm mornings of sleeping in and cuddling.

We bought a house and moved yet again. This time, we were lucky to find a daycare that happened to be directly opposite our house. I got pregnant again. I gave birth to a beautiful baby boy. He will start daycare at six months as well. I decided not to feel guilty this time.

As it turns out, I didn't feel guilty at all. By now, I was familiar with the routine of bringing him in, nursing him at daycare and picking him up. He started with three afternoons a week. I use the time he's there for writing, reading, running errands or simply relaxing. I am glad that I have this possibility.

When it's time to pick him up, I have missed him a little and I am also glad to have him back home. I am also glad to spend full days with him.

In short, the flexibility and quality of Dutch daycares allows me to be the mom I want to be: one that is relaxed, calm and understanding instead of frazzled, stressed and overwhelmed.

Obviously, I get my share of bad days, too. But my daycare helps make them a little bit better by giving me the time for myself that I so desperately need.

Olga Mecking is a Polish woman living in the Netherlands with her German husband and three trilingual children. She is a translator, blogger and writer. She blogs at The European Mama, a blog about her life abroad, raising children and travelling. She also is a regular contributor to World Moms Blog, BLUNTmoms and Multicultural Kid Blogs. Her writings have been published on Scary Mommy, Mamalode and The Huffington Post. When not blogging or thinking about blogging, she can be found reading books, drinking tea, or cooking.

How high do parents raise the bar?

Lana Kristine Jelenjev
Smart Tinker

"No I don't want to read and do math, I will only do that when I am in group 3."

The line reverberated through my head the minute it was spoken by our four year-old daughter right after a few weeks of stepping into Group 1 in *basisschool* (primary school). My thoughts went from "Where is my little girl who at age three knew her letter sounds and was beginning to piece them together?" to "Where did we fail in instilling in her that she can keep on learning and learn in a way that challenges her?" After those thoughts came the harshest thought of all, "How dare her teacher say that to her?"

Being an educator myself, I specifically chose to send our daughter to a Montessori school with the notion that she will grow best in such an environment. The school system is very different from where I come from, and in the Philippines you either get a private education or a public one. The level or depth of instruction that you receive depends on the status of the school. We were not rich, but my mom (who put my sibling and me through university after separating from my father) instilled in us the value of education, so much so that she took odd jobs to get us through our schooling in one of the prestigious schools in our city.

My entire school life was devoted to getting good grades, being in the top students' list, participating in contests and being part of academic clubs. I wasn't the brightest in the class, but I was still part of that elite group of students that was called upon to represent the school at different events. I had a ranking to maintain and I did so all throughout my academic life. There was no "Oh you can only do that when..." line given to me. There was always "As long as you try, you can."

I was deeply dumbfounded when I heard my daughter say those words. I was faced with the looming reality that what we were facing now was not just a problem with that particular teacher. It went deeper than that, and stretched far into a cultural perspective that permeates the

educational environment. It is connected to the *gemiddeld mentaliteit* (average mentality) that educators and school administrations espouse. I was faced with the dilemma of understanding the Dutch schooling system and culture and reconciling those with the value of education and fervour in schooling that was instilled in me throughout all the years of my academic life.

I started looking into the Dutch's perception of normalcy. *"Doe maar gewoon, dan doe je al gek genoeg"* is a very common line that, when roughly translated, means "Just be normal, that is crazy enough." But my thoughts continued to rage, and my questions kept pouring in.

What is the norm?

What constitutes going beyond it?

What fits in the "average mould?"

Why is a score of 6 good enough (known in the Netherlands as *zesjescultuur*)?

Why do people place the average mentality on a pedestal as a virtue?

Why can't anyone simply do the best that they can do?

Why does this culture value that it is good enough to be like everyone else?

Onderpresenteren (underachievement) is a very big issue in the Dutch educational system. Even the Secretary of Education placed emphasis on showing excellence, saying *"Excellentie mag gezien worden"*, or excellence can be flaunted. Essentially, that it's okay to show excellence. Educational reform is one of the primary objectives to stop the stagnation that is setting into the educational scene. But how do you keep a people from going against their culture?

I had a discussion on the *zescultuur* with my husband, and although we both agree on the importance of grit, fervour and rigour in learning and education, I am extremely wary of how our children's world can go against those principles.

We continue to face questions. Are we setting up our kids to be complacent? Are we setting them up for failure? How can we instil in them a love for learning, not just learning to get a *voldoende* (passing grade)? The kind of learning that goes beyond what is expected?

It is pretty obvious that I hold education in extremely high esteem. I know what lengths my mother, and also my grandmother (who helped support both my brother and me when we were studying), went to for our education. These two women served as pillars of hope and determination because of what they did for my older brother and me, not only to get us through school but also to give us the best possible education that we could have. I would not want their sacrifices to be in vain.

So, now what to do?

I would do what any other parent I know who loves to see their child pushing his or her own boundaries is doing. I would look carefully at our values and ask myself, "*Hoe hoog leg jij als ouder de lat?*" or, as translated, "How high do you as parents raise the bar?"

Lana Jelenjev works as an educational consultant though what she likes the most is being a parent. It has taught her valuable life skills such as being compassionate to herself and using that in her parenting. She also loves sharing her experiences and getting engaged in thoughtful discussions about parenting, children and education. <u>Smart Tinker</u> is her brainchild, born out of the need to share her knowledge and expertise in the field of early childhood education, parenting and curriculum innovation.

X

Dutch Doctors

The quirks of healthcare in the Netherlands

Amber Rahim

Amber Rahim Coaching

My first experience with the Dutch healthcare system was with my quirky *huisarts* who, after welcoming us and taking a medical history, told us he never wanted to see us again. Laughing, we promised we would do our best to stay away from him.

A couple of years later I was sent away again, bemused this time. I am from the UK and there, a midwife from your local doctor's practice gets assigned to you (who knows, maybe that has changed in recent years). So I was surprised by his surprise that I had come to see him after doing a pregnancy test at home.

He congratulated me and basically asked me what I was doing there, in his office.

"I don't know" I replied, "aren't I supposed to come and see you about this?" There was a look in his eyes that seemed to say 'only if you think I'm the dad' but he actually just informed me that I could just choose my own midwife. As we didn't live in the area anymore he advised me to Google it.

Huh? Okay. For me this level of choice in healthcare was unusual and a little unsettling. When it comes to healthcare its so common to "get what you're given" and the Dutch just break that down with an attitude of "you're the patient, you have a say".

Yet how would I know where to find a good midwife? Just as with many things I am not good at, I delegated this task to my particularly talented Googler, my husband.

We don't use the term "we are pregnant" (I have only heard that in the Netherlands) but he gets seriously involved in everything related to parenting.

We found a good midwife and we were set. To be honest, at that stage, I wasn't up to the whole process of interviewing different clinics to see which one I liked best. I had no idea what I was looking for.

At 26 weeks I sought out my midwife because something was wrong.

They put aside that *laissez-faire* attitude and gently took charge. I was presenting as full term and that was not good. When the proverbial hits the fan the Dutch pick up speed and get down to business, while maintaining that calmly relaxing energy.

This is what happened.

I got sent to the hospital for a scan and they saw that I had a huge amount of amniotic fluid, more than seven times the normal amount.

Ignoring their flurry of activity and widening of eyes in shock I focused on trying to prevent them from telling me the gender of my baby. Practically everyone here knows from their first echo and shares this information with the world. It's the first thing you get asked when you share your good news. I don't know which bit was more surprising for them: the flood of waters that were about to break or me not wanting to know the gender of my baby.

As with all things related to water management, the Dutch always turn to the experts so the hosptial referred me another facility. They explained that I probably needed a procedure and in the event of complications, I would need to be transferred there anyway. So without delay they arranged an appointment for us.

I am grateful that on that day I didn't meet an arrogant doctor who disregarded risks (they do exist!). I can't bear to think of what might have happened.

The new facility was an academic teaching hospital and that teaching/ learning culture exists not only among the students but the qualified doctors too.

We were greeted by specialists and a whole team of students. There was something wrong, either with me or with the baby, and they were going to work through the list of possibilities to rule them out.

Not all hospitals are equal and not all experiences are good. I have heard some stories of terrible incidents and have experienced the occasional nightmare myself but there is a culture of choice here in the Netherlands when it comes to healthcare. Maybe this is the reason that doctors are willing to listen to their patients, especially when you make them.

Every hospitalization of my daughter (and we have had a lot) ended with a feedback session on what is working in the children's ward and

what could be improved. They may not have changed hospital policy because of what we said but we built a relationship, an understanding that lead to a happy cooperation between parents and staff.

Overall I have seen medical personnel who are interested in what we, patients and parents, have to say. They ask and even listen. We have the responsibility to speak up and be direct. We're in the Netherlands, speaking up is expected!

Amber loves her work as a leadership coach where teaching others to make conscious choices and to be the lead role in the story of their lives. She unleashes her own creativity onto the world through her writing about being a parent of a child with chronic illness at www.amberrahim. com. She has two daughters, a stepson and a Dutch husband. She loves living in Amsterdam where there is always something new to discover. Amber is a mother, wife, daughter, sister, parent, carer and coach. Oh, and sometimes, she's just herself. For about 5 minutes a day. She has ambitions to make that 20 minutes a day.

How sick are you?
Lynn Morrison
The Nomad Mom Diary

It is obvious to me that Joseph Heller never lived in the Netherlands. If he had, he would have made a Dutch doctor's waiting room the central location of *Catch-22*.

You see, if you are sick enough to justify a trip to the doctor, you will not have the strength and fortitude needed to fight your way into an appointment. Conversely, if you have the wherewithal to survive the numerous roadblocks, you will be deemed too well and sent off with a pseudo-prescription for paracetamol and bread.

After four years of living here, I have learned the two secrets to survival: a well-stocked medicine cabinet and a friendly doctor back home. The first will help you survive most of the common ailments (cold, flu, fever, pain, migraines, viruses and other annoyances) by providing the drug-induced fog that should make you feel exceptionally entitled. The other will make sure that you will get a flu shot.

Sometimes all of your best efforts are for nothing. Sometimes you get struck down by some damned foreign bacteria that refuse to budge despite copious amounts of rest, alcohol and *bitterballen*. When this happens, you have no choice but to go to the doctor. This is what happened to me.

In four years, I have been to the doctor twice. The first time may or may not have been because I fell off my bike while I may or may not have been trying to jump up on a curb. The second time was due to an invisible bungee cord that kept pulling me back into my bathroom. When gangrene started to set in in the first case and I began debating leaving my husband to elope with the toilet in the second, I knew I needed help. Wouldn't you know it that both times the doctor was away on vacation?

Seriously, what are the odds? Roadblock #1 is definitely absence.

I trucked it over to see some completely apathetic fill-in doctor who knew that he would never have to see me again after the end of that week. I was saved the first time only because injuries that keep you

off your bicycle are viewed as life threatening. I was immediately prescribed antibiotics and was back to normal within a few days. The second time, however, I was not so lucky. That doctor prescribed total inaction—no meds, no rest and respite for the weary. I should just let it work itself out naturally.

I sucked it up for another week and tried to convince myself that the weight loss from my stomach bug was worth the pain and suffering. It was faster than Weight Watchers and I could eat anything I wanted. Of course, I felt so bad that I didn't want anything, but that's beside the point. Eventually my husband started threatening that he was going to leave me and I knew I was going to have to call the doctor again.

This is where I encountered the second way doctors here avoid seeing you. If you manage to catch them when they aren't on vacation, then they purposely screw up the appointment time.

"You can come at 3:50." "3-5-0 or 3-1-5?" "3-5-0."

I showed up and waited and waited and waited until I was the only one in the waiting room at 16:30 on a Friday. What was the assistant's response?

"Your appointment was at 2:50." "But you confirmed 3-5-0!" "No, I said 4-5-0 for 14:50."

Never mind that 14 and 3 don't sound remotely alike in any language, that was her story and she would not budge. The next appointment was five days later. Five days of pure hell later, I must add.

When I finally did manage to get in to see the doctor (only after calling the emergency line in the middle of the day and crying profusely), I encountered the last barrier: the specialist. You see, when you have a persistent illness with obvious side effects that cannot be ignored (in my case, a loss of six kilos and low blood pressure), you get referred to a specialist. Why? Because you must be dying of a serious illness. Otherwise paracetamol and time would solve it.

The good news is that if you can get the golden ticket to visit the specialist, the wait is non-existent. Duh. No one can get past the gatekeepers. Two days and 20 minutes with the specialist later I had my magical potion: antibiotics.

Here is my advice to the rest of you if you find yourself in my position.

Don't wait weeks. Lie right up front about how sick you are. Go at least two days without showering, brushing your hair or your teeth before visiting the doctor. Then put on your best "death's doorstep" face and head into the office. Then and only then will you have some hope of beating the Dutch doctor Catch-22.

Lynn Morrison is a smart-ass American raising two prim princesses with her obnoxiously skinny Italian husband in Oxford, England. As the Nomad Mom, Lynn exposes the truth about what it's like to be married to an uber-brainiac and the mother to multilingual children. The truth is, her days are pretty much like everyone else's, just with more pronunciations of the word "water". Lynn likes nothing better than to curl up with her MacBook and a glass of wine and write thought-provoking essays on why sweatpants are the new black or why it is impossible to suck it in for eight hours. If you've ever hidden pizza boxes at the bottom of the trash or worn maternity pants when not pregnant, chances are you'll like the Nomad Mom Diary. *You can also find Lynn over on* BLUNTmoms, *Scary Mommy, Mamapedia, Bonbon Break and on* the Huffington Post.

That's a helluva exam
Molly Quell
Neamhspleachas

A few weeks ago, I got a letter telling me I was old. Well, not in so many words. I got a letter, from the government, saying that because I am turning 30 this year, it's time for a Pap smear.

In the Netherlands, women only start getting Pap smears done when they turn 30, and then every five years. In the US, you typically start getting them done when you become sexually active or when you turn 18. From then on, you have them done once a year, during your yearly check-up, although now the recommendation has changed to every three years.

Needless to say, I have had plenty of Pap smears done.

I call my doctor's office and make my appointment, indicating that I got aforementioned letter. When I arrive several days later for said appointment, the receptionist asks me for my name and the name of my doctor. I tell her, and she looks at me and says "He's not in the office today."

I shrug. "Ok."

"Well, then you can't have an appointment with him."

"Clearly not."

We are at an impasse. I politely tell her that simply because my regular doctor isn't there, it doesn't mean that I don't have an appointment with another doctor and perhaps she should check her computer for just such a thing.

She asks me what time my appointment was.

"I think 11:30."

"Well, there's no appointment at 11:30."

I take a deep breath. "Could you check to see if I have an appointment today?"

She asks my name again and consults the computer. "Yes, at 11:25. You can take a seat."

I blink several times and join the crowd in the waiting room.

A few minutes later, my name is called and I introduce myself to the nurse who, as I very quickly realize, isn't especially well versed in English. She has an assistant with her who, apparently, speaks no English at all.

We go into the office and the nurse asks me to sit, so that she can explain the procedure. After a few minutes of tedious attempts to explain in English, supplemented by Dutch, I tell her not to worry. I've had a Pap smear before and I understand the procedure. The nurse eyes her assistant.

"When was your last exam?" she asks.

"A year or so ago, the last time I was in the US."

"And why did you get it done?"

I try to explain that it's very common in the US. to have your first Pap smear at an earlier age and that you get them more regularly there. The nurse and the assistant exchange sideways glances.

"We have some more questions," the nurse tells me.

They proceed to ask some rather probing questions about my sex life, sexual activities, sexual partners and all manner of sexual habits. As I haven't actually been a nun for my entire life, some of my answers are vague. This only seems to upset them more.

Eventually, the nurse declares that I need to talk to the doctor. She disappears from the office and leaves me with the assistant who just stares at the floor. The nurse returns and tells me that there are no female doctors available, so I will have to wait.

I raise my eyebrows. "Are there male doctors available?"

"Yes, but do you want to see a male doctor?"

"Yes, that's fine." I've already been here for an hour, I haven't had the exam and I've got work to do. If they gave a chimpanzee a medical degree, I'd talk to him. Or her.

The nurse again departs and returns with a man who is at least 85 and probably speaks about as much English as your average chimpanzee. He repeats a number of questions I've already been asked and, at this point, I'm beginning to get irritated.

"Look," I finally say, "I've answered these questions already and I'm failing to see how any of them are relevant to getting a Pap done."

The doctor and the nurse exchange uncomfortable glances. The assistant continues to stare at the floor. The doctor nods and says ok.

The exam, is, as expected, a pretty standard Pap smear experience. Once it's over, the doctor states that he wants to take a blood and urine sample because, he says he's "concerned about infection."

Considering this gentleman had just had a more intimate moment with my private parts than I am able to have, I grow concerned. "Is something wrong?" I ask.

More uncomfortable glances. "No, no," the nurse says, "Just in case." She hands me a sample cup. I go to the bathroom, lock the door and do what any foreigner would do. I call my doctor back home.

After answering a series of questions about pain (I have none) and discharges (also none), she tells me that there's nothing to worry about and chalks it up to a language barrier. I return my sample, say my goodbyes and roll my eyes about the absurdity of the Dutch medical system.

The next day, my phone rings, and it's my regular doctor. For the record, his English is perfectly fine.

"So," he starts awkwardly, "I hear you had an appointment yesterday."

"Yeah, it was a bit odd," I tell him.

"I heard as much. As you know it's not common for women here to get Pap smears until they are 30."

"Right."

"And, typically, the only women who do get them earlier or more often work in certain areas…"

"Your colleagues thought I was a hooker?"

"I think we would say sex worker, but yes."

"I hope you clarified things."

"Well, I just want you to know that if you are participating in or contemplating that sort of work, I would want to know, as there are certain health precautions…" he went on, explaining that sex work

is legal in the Netherlands and I'd still be a welcome patient at their practice.

The Netherlands. Where regular medical check-ups are strange, but sex work is welcome.

Molly Quell works as an editor and online marketing consultant and spends her free time listening to NPR while baking cookies and drinking beer. Originally from the United States, sort of, she blogs irregularly at Neamhspleachas but contributes to a variety of publications. You can see more about her professional work at www.mollyquell.com.

XI

My Dutch Life

A bittersweet saga of hilariously dramatic efforts
Alexia Martha Symvoulidu
The Non-Hip Hippies

August 18, 2010, 14:00, Schiphol Airport.

I can do this. This is glorious. I am starting a new life in a new country where the streets are clean, the people are polite, helpful and efficient, the beer is cheap, the fries readily available and the cheese is plenty and delicious. I am coming with a big suitcase and I will leave in two years with a master's degree in architecture, a new language, tons of new Dutch friends and wonderful memories in my luggage. This is going to be legendary.

September 1ʰ 2010, 18:00, TU Delft, Faculty of Architecture.

A voice is heard from the speakers: "The faculty is closing soon. Make sure to take all your belongings."

How is this even possible? It is ridiculously early. Am I really supposed to force inspiration to serve me nine to five? How do these people do that?! I just got warmed up and there is no way I can carry this half-finished model back to that tiny dorm room. I am doomed. I will fail every single lesson.

How do the Dutch do it? How do they leave their design work in the middle, go drink a couple of beers and just get back to it the day after? It's supposed to be a creative endeavour, damn it! We are not just stamping papers here!

November 20, 2010, 14:00, TU Delft, Faculty of Architecture. Midterm presentations.

Finally! I did it. I am definitely not particularly proud of this project, but it is done and it is done on time. My professors back in Greece would faint if they saw how superficial all this is. On the other hand, if they had bothered to teach us how to make a proper presentation, I wouldn't have wasted so much time on it now. At least my posters look neat for

the first time in my life. And people asked questions about the project. If you asked questions about someone's project back home, you were considered either an arrogant smartass or a desperate attention seeker. I think I like it better here after all.

February 2, 2011, TU Delft Campus, The Spaceboxes (student housing containers.)

I hate it here. Where is the sun? Why is it so freaking freezing? I am going to die of vitamin D deprivation. Why are the laundry machines not working again? Why didn't anyone warn me about seasonal affective disorder? I am sure I have it. When is the snow going to melt?! How many more months of these polar conditions? Why does my Spacebox tremble so much? There are no earthquakes here, are there? Ahh, it's just the trucks passing by. Oh, and the wind. And where is this techno music coming from? Who is in the mood to party with all this gloom around us?

June 14, 2011, 18:00, TU Delft, Faculty of Architecture, Bouwpub (the bar of the architecture faculty.)

I love everyone here. They are all my friends. Yes, I am drunk, but still, I am sure that all these people asking me where I come from and what my plans for the future are really care about me and want to be my best friends for ever and ever. Look how cheerful everyone is! I passed all my courses, so I am finally getting how this system works. I am efficient, I am effective, I am professional, and I am pleasant. I am becoming a true European day by day.

June 15, 2011, 07:45, TU Delft Campus, The Spaceboxes.

Why, oh why, do I keep drinking that crappy wine, when all the wise Dutchies stick to beer? Why didn't any of my new friends call me today? Are we not friends? Friends? Where are you?

October 23, 2011, 13:00, TU Delft Campus, Internship Office.

This is great. They let me do my second master's year and an internship

at the same time. They trust me. I can do this. I earned this. I am really becoming a fighter here. This country gives chances to ambitious architects, no more Greek misery for me! The professor wants me to call him simply by his first name. So do the other colleagues. No authoritative bullshit. No stupid hierarchy rules. Just hard work and mutual respect. I love it here.

April 20, 2012, 14:15, TU Delft Campus, Espresso Bar.

My daily supervisor wants to have a chat.

"I am not saying you can't graduate on time. I am just suggesting that if you work a couple of months more, maybe you can produce better material and then it would go into one of our publications. We are not even talking about a full semester. Let's face it. There are many things you can improve, so we have to see if you are ready".

No, no, no, no, not the same story again! I've been there, done that back in Greece. A year's delay just to turn good into perfect, while everyone knows that perfect does not exist. And what was that last phrase? Am I being threatened that I won't be allowed to finish on time? What about the promises of being hired after the summer? What happened to that? That's not good.

April 20, 2012, 16:30, TU Delft Campus, Bouwpub.

Shit seems to be the same here, when it comes to graduating. Apparently, they will try and squeeze you like a lemon before they let you go. That's why everyone gets so drunk every Thursday. It makes sense. I hate everyone. No hierarchy, yeah sure.

June 14, 2012, 15:00, TU Delft Campus, Graduation Presentation Hall.

I am done. This roll of paper in my arms will open all the doors for me. Architecture firms all around the Netherlands are eagerly waiting to receive my CV. But I don't even need to send my CV out there, because my professor has already said he wants me at the office, or to continue my research at the university. I might not have managed to make any real friends, due to the competitive nature of the studies, but

professionally my future seems to be bright. Good days are coming.

July 25, 2012, 14:00, Rotterdam, Big Architecture Office.

"You see, the crisis has affected us a lot as well. We are letting employees go and hiring interns in their place. Things are tough. The university has no money to fund researcher positions. Oh, a PhD you say? Starting this year, architecture PhD students have to pay fees for that. Yes, I know everyone else is getting paid. Horrible, isn't it?"

Fine. I just have to send those CVs after all. But why is it that I have this disturbing feeling of betrayal? Why do I feel I have been played around and lied to a couple of months ago? What happened to the Dutch directness and honesty back then?

August 30, 2012, 21:00, Delft, my room in a shared house next to the canal.

I guess I will have to learn Dutch in the end. So much for the international working environment. It seems I am overqualified, now that I have a degree and everyone needs cheap interns. At least my lovely housemate keeps bringing me those delicious comforting Asian infusions. She doesn't mind my boyfriend sleeping over almost every night. She cooks wonderful food. And she tells me I am pretty and talented. I wonder why I was so hesitant with adopting that Dutch house-sharing model. It's the only thing that seems to improve my life here at the moment.

September 20, 2012, 08:30, Den Hoorn, on my first bike.

What on Earth was I thinking? The sun is not even up yet, it's raining and I keep sliding back on all those cute little bridges, while trying to balance on that bike.

"Careful! A car is coming!" shouts my boyfriend, cycling behind me.

Great, now I am in panic. Out of balance. On the ground. Again. My knees are scratched but my jeans are intact. Muddy, but intact.

Surely, that Dutch teacher in Den Hoorn is affordable (ok, cheap) and speaking the language might increase my chances of getting a job. But

is it really worth all this hot mess?

October 3, 2012, 11:00, Delft, Chamber of Commerce (KvK)

"Congratulations on opening your company. You will find all the information you need in English on our website and we will inform the tax office. They will send you mail to inform you about your tax obligations. Do you have any questions? We are here to help you."

Ha! I've got my own company. I am a freelancer. I am, therefore, FREE. I will make my own living, using my writing skills. I don't need any of you arrogant "starchitects" to take advantage of me and have me working 20 hours a day in your model-making, dimly lit basements. This really is the land of opportunity for young ambitious youth.

December 20, 2012, 10:00, Delft, my room.

Someone on the phone speaks Dutch to me "bla...bla...bla... Belastingdienst...bla...bla...".

No, they can't speak English to me. No, they are not allowed to. I could go there with someone who speaks Dutch. No, the KvK is a different story. The tax office staff will, under no circumstances, speak English to me. Sigh.

December 21, 2012, 14:15, my accountant's office.

I am really a grown-up. I have an accountant. How cool is that? I live in the Netherlands, have my own business and an accountant, to deal with the tax office. And I am writing for clients all over the world. How international of me!

January 1, 2013, 09:00, Delft, our new home.

So I guess this is a new era. We live together now; we have a proper house, no housemates, our own laundry machine and grown-up neighbours with kids. He has a stable job at the university; I have a not-so-profitable job as well. What's happening? Are we really starting our life together here? Do we start to grow roots in this country? If so, why do I have exactly one true friend here—who happens to be Finnish and

not Dutch?

February 20, 2013, 22:00, Delft, our new home, Skype call with our families in Greece.

"Yes, we are getting married. No, we will get married here, in Delft. We just want those close to us to be there. Our home is here now. No, it will just be a quick ceremony at the municipality. You know we are not religious. Of course there will be a party afterward!"

I can hardly believe we are doing this, even though I feel sure it's time to take the leap. I love that we have the option to keep things low-key and are not expected to marry or to start a family here. I love that if my gay friends decided to get married, here they would have the option, while back home they don't. Even if you decide to get married, you are not expected to have a giant, kitsch ceremony and reception. Sometimes I really love the Dutch mentality.

June 10, 2013, 19:00, Delftse Hout, our wedding party.

This is just sublime. I just got married to the man I love, I am in a pedal boat, wearing my hippie wedding dress and white All-Stars and flowers in my hair, drinking white wine, watching the people I love laugh in other pedal boats scattered around the lake. Everything is green and the water is calm and the sun is still high up. There might be exactly zero Dutch guests in our reception, but there are about 10 international ones. We might not be integrated, but we do have a community here. I feel the love all around me.

October 6, 2013, 08:00, Schiedam, our new home.

I love this place. It is affordable, it has a garden and a great orientation, which allows the weak Dutch sun to penetrate it and warm its soul. My husband has to commute to work to Delft every day, but that is typically Dutch anyway. At least we have gotten used to the Dutch mentality in some ways. I'd better pack his lunch, for I hate to think that the man I love has to eat cold bread and fried unidentified stuff. I think that, apart from the fries, we will never get used to Dutch "cuisine."

January 7, 2014, 17:00, Delft, midwife practice.

"It's a girl and she looks really healthy. Congratulations!"

I love my midwife practice. I love the Dutch mentality regarding childbirth, totally opposite to the Greek, over-medicated one with the 40% caesarean section rate. I should write an article about it.

February 9, 2014, 21:00, Schiedam, our home.

Why on Earth did I write this article? How ignorant was I about the conflict of midwives and doctors in the Netherlands? Why do people keep sending me those Facebook messages, telling me to go give birth in Belgium if I want to survive? Did I make a horrible mistake? Why are there so many expat women with traumatic experiences? I am doomed.

February 9, 2014, 23:30, Schiedam, our home.

False alarm. I will survive. Expat birth survivors in the Netherlands spotted all over the country. Internet trolls also spotted on my website.

Today, May 10, 2014, 12:39, Schiedam, our home.

Almost four years in the Netherlands. Less than four weeks until my due date. Four times have my parents from Greece visited us. Four people we feel comfortable to call, if we are in trouble here. More than four hundred words I know in Dutch, none of which I dare to speak, as everyone replies in English. Four Facebook groups of expat parents I follow and find very helpful. More than four times a day we think about raising our first child here, the country with the happiest kids in Europe, instead of our homeland. Half the times it sounds like a good idea, the other half it sounds depressing. More than four dozen times have I cried, because I miss home. Last year, I have cried less than four times for that reason. For, integrated or not, the Netherlands is a good place to live, after all.

Alexia Martha Symvoulidou is a freelance writer and designer with a

ten-year background in architecture. It took her a while to find her real calling, but has been happily typing away the last two years, working from home. She shares said home with Nikos, her husband, Noah, the rabbit, Mr. Fthoggos, the hedgehog and many succulents. She is also mom to Loulou Maya. She blogs about food, living abroad, social justice and sustainable living at [The Non-Hip Hippies](#).

A love affair called Amsterdam
Shivangi Tiwari

Amayzmom

It was 2006. Back then, 2014 seemed eons away, a whole eight years ahead, during which, the world was supposed to end. I had just drafted my resignation letter from my job, as I was going to start business school in about three months. I had never been out of India in my whole life of 26 years. My manager got off a call with an overseas client and called me over for a chat. He had promised the client that he would send someone to their site for a few months as a consultant. The client had agreed to bear all expenses for that person.

Lo and behold, that someone was me, and that site was Amsterdam!

It was too good to be true. I was to spend the three months of my notice period in an all-expense paid trip to Amster-freaking-dam, and I was to fly in the next couple of weeks.

So this was it, I thought. I was going to live my life in those 90 days. I was single, I had just put in my papers and this might be my only chance to be in the most decadent place on planet. A place where weed was served at breakfast by naked people or such. A place where the sun never really set. Only later did I realize that the sun never bloody rises here.

I remember going to The Grasshopper with three of my friends on the first weekend, although I can't exactly recall who among them dragged me up the two flights of lethal Dutch stairs that led to my apartment at 4:00am. Bless them. On non-hung over mornings I was ready at 8:00, with sneakers, city guides and maps, ticking off every museum and every other touristy sight one by one: windmills, Zaanse Schans, clog making, cheese factory, Madurodam, and all that shebang. I was never going to come back here, so I packed plenty of souvenirs and memories on my return.

My passport was no longer a virgin, so I could die peacefully even if the world was indeed going to end. I finished my MBA, got married and moved to Singapore, and a couple of years later, to Hong Kong. Then in 2010, my husband was offered a fabulous job, the only condition being

that he was to move to a place about 6,000 miles away.

That place, again, was Amster-freaking-dam!

This time the decision to move was bigger, as was the potential distance from our families. It meant moving our whole house and for me, finding a brand new job. But I easily found one, so we decided to take the plunge and move back to Asia in a year or so. It would be a nice break to be in Europe and travel around, we thought. We were a carefree DINK (Dual Income, No Kids) couple back then—oh those pre-baby days of yore! The weather looked inviting to us tropical mortals. Relief from a scorching 35 degrees Celsius was always welcome. We had grown up to anticipate rains all our life, singing songs to summon them or sailing our paper boats while dancing in them. Rainy season is considered as a season of romance in India. Going by that logic, the Dutch should be the most romantic species of humans on this planet.

Of course there were some very beautiful days in Amsterdam when you could actually, you know, see the sun with the naked eye. On such days I had a strong urge to quit my job and sit at home. But it always rained the next morning, even before I had typed my resignation letter. We never bought a lot of furniture, as we were not going to stay here for long. For the same reason, I never made an effort to learn Dutch. Besides, I knew I'd suck at remembering words that were longer than my arm and could never harrumph the way these cloggies do to save my life. The best things in life are free, and Google Translate is one of them.

For an Asian, the work culture of the Netherlands can be very different, to say the least. We come from a place where grocery stores are open 24 hours a day and where you can call a plumber at 20:00 to fix your broken tap. Here, the whole working population literally shuts down and goes boating or fishing for herring at 17:00. Once I rushed to a post office to arrange a courier at exactly 17:01 PM, and wasn't entertained.

Important work matters were discussed over multiple rounds of *borrels* involving deep fried meat snacks. You had to align with everyone and their cousins before making even the smallest of decisions. You had to toot your horn to even the office café worker about the latest awesome project you were doing. I was told by my (expat) manager once to be more Dutch at work, the humble Asian that I was. Group lunch events at

work meant a total of three different types of dry sandwiches, with one jar of orange juice and one jar of milk on the side. A senior director who was entitled to a car at work was seen riding her *bakfiets* to office in the rain, wearing white pants. It was a crazy place. The one year of our originally planned stay ended, and I had just about learnt to use *gezellig* in a sentence that made sense. "I don't think I want to move back so soon," I told my husband. "I was thinking the same," he replied. So we stayed on. Another year and then we'll go back.

Another year passed. Just when we were starting to discuss our options to return, we thought we should add another variable to the mix and confuse ourselves royally. So we decided to have a baby. Somehow it seemed a good idea to have one right then and right where we were, planning be damned!

I peed on a stick and ran to my doctor right away. He didn't see the need to confirm my pregnancy through any test. Although he did calculate the due date of my baby through a very state-of-the-art gadget: a small piece of cardboard that was cut in a circle and had dates printed on it. By moving another smaller cardboard circle on top of that, he told me that my child would be born on August 22, 2012. He handed me a letter for my midwife and informed that doctors are not really involved in pregnancy and birth in the Netherlands. I should have to run back to my country right then, but something told me I should stay.

I went overdue by two weeks, but they never forced me to induce labour artificially. I asked for an epidural and they told me I had to take it before 22:00 or never (preferably never), as the anaesthesiologist didn't work beyond that. The doctors never prescribed antibiotics until it seemed necessary, regardless of how much I craved a shot of amoxicillin on the rocks to tame my sore throat.

My son will celebrate his second birthday soon, and we will celebrate having lived and worked five years in Amsterdam. I have seen three different phases of my life here: reckless "where-is-the-party-tonight" singlehood; conjoined "honey-we-need-to-go-to-IKEA-this-Sunday" marriage-hood; and ever-demanding "is-there-a-toddler-playgroup-around-where-I-live" motherhood. The city never failed to pleasantly surprise me with all that it could offer at every phase. I don't know what it is about Amsterdam that makes me feel so at home.

Maybe it is those colleagues who want to keep everyone happy and therefore take a lot of time to make decisions. Maybe it is the society at large that does not blindly run after creating wealth and takes pride in what it does, even if that means turning away a customer at 17:01. Maybe it is the sheer beauty of this place, which is not tarnished by concrete towers and poisonous gases emitted by cars that were rejected by senior managers in favour of the eco-friendly *bakfiets*. Perhaps it is those relaxed doctors who turned a hypochondriac, pill-popping me into a person who is more in tune with nature and her own body. Maybe it is the fact that I haven't had to learn Dutch in all these years and I am still not treated as an outsider.

Maybe it is the lovely, ever-smiling, ever-helpful Dutch people and their quirky sense of humour.

A conversation with my Dutch gym instructor illustrates this really well:

"So I haven't seen you in while."

"Yes, I had a baby so I wasn't much into fitness"

"You HAD a baby? You do still have him, right?"

Yes, that sounds about right. It is definitely the sense of humour that makes me stay on, because it is certainly not the food.

I do wish to go back to my country. But I don't want to leave Amsterdam; I have no reason to.

Can both please somehow be simultaneously possible?

Shivangi has been writing for longer than she can remember and her work has appeared in various women and parenting websites and magazines. She lives in Amsterdam with her husband and 2-year-old son. When not picking things from floor that her son has spilled yet again, she works as a digital marketer. She studied engineering followed by an MBA, and has worked in the corporate space for over a decade in four different countries. She is originally from India and she blogs at Amayzmom.

Showing my butt in Oud Zuid
Catina Tanner
Amsterdam Mama

Where I come from, when someone displays inappropriate behaviour we often say, "Wow, so-and-so is really showing her butt."

Hasn't everyone shown their butt at least once in life? I know I have.

However, it wasn't until recently that I showed my butt in a more direct, Dutch way. I showed my butt, literally, to half of my kid's schoolmates, their parents and faculty of their school.

My son was in a bike accident and had to wear a cast on his leg for several days. He had crutches to get around on, but walking up the tiered cement sidewalk to the school entrance was a bit too much for him.

In a rush to get him to class on time, I scooped him onto my hip and up I sprinted with my son wrapped around one side of my body and an arm full of backpacks and crutches on the other.

It wasn't until I got to the top of the steps that I felt a draft creeping up my leg. Something just didn't feel right. That was when I reached my hand around to my backside and felt the silkiness of my exposed pantyhose. My son had not only wrapped his legs around my waist, but also hiked up the back part of my dress.

First of all, I felt sorry for all those exposed to such a sight first thing in the morning. It had to be traumatic. Thank goodness I had on my granny panties and not a thong. Then again, the climbing had jacked the grannies halfway up my crack. Why hadn't I put on black tights instead of nude hose?

Can you imagine my embarrassment? It's not like I have the butt cheeks of a Victoria's Secret model. If I had one of those rear ends, I would wear a thong bikini for the school run. No, I like to keep covered these days, especially after having two kids.

I frantically looked around to see if anyone was staring, passed out from shock or trying not to notice. I put my son down, slowly pulled the dress over my rump and we made our way through the school hallway.

There were no snickers, no whispering, nothing. Everyone kept on going, business as usual. It was only then that I could feel my embarrassment slowly fade away. So I giggled to myself and held my head up high.

It's not that people didn't see my ass hanging out. I know they saw it. But that is what I love the most about the Dutch, you can just let it all hang out and they don't judge you. The Netherlands is a place I can safely be myself, granny panties and all.

Catina Tanner was born and raised in the southern US but for the past 13 years has called Amsterdam her home. She is a communications professional for an international criminal court though her most treasured title is mom to her two half-Dutch children. She blogs about her experiences as an expat mother at Amsterdam Mama. You can also find an article or two on the web she has written in between bouts of sleep deprivation. Her two dreams in life are to become a writer, and to someday have children who sleep through the night.

I love the weather in the Netherlands
Tamkara Adun
Naija Expat In Holland

I come from the tropics where it's warm all year round and, because of this, I am constantly asked "So what do you think about the weather in the Netherlands?" or "How are you coping with the weather?" by my Dutch acquaintances.

My response is usually: "I am coping just fine. In fact, I love the Dutch weather."

Then I get the look. The puzzled look that silently inquires whether I am one of those overly positive types. You know, the ones who can make lemonade out of lemons, lime and marmite. Which I am, by the way.

I try to explain.

"You see the weather in the Netherlands has been kind to me," I begin then I launch into my tale.

At the end, I am never quite sure if they are convinced that I love their weather. I usually get a shrug and one final look that says *"Ieder zijn meug,"* which in English means "to each their own."

I am always the one in the room who feels the coldest, the one who needs the extra jacket. It has been that way for as long as I can remember. A little wind and I feel the goose pimples cropping up one tiny bump at a time. A friend once put it down to my having a thin subcutaneous layer of skin, whatever that means.

When I first arrived in the Netherlands, autumn was just rounding up and giving way to winter. It was slightly chilly, but I didn't mind. I fell in love with the flowers with their vibrant colours that seemed to me like they had been painted just yesterday. I inhaled the intoxicating smell of fresh crisp air, which tantalised my nostrils with the scent of earth, trees and nature all rolled into one exhilarating perfume. I was giddy and besotted with the Netherlands.

I loved the dramatic Dutch skies with their soft and fluffy clouds like white candy fluff. Clouds so luscious and large enough to stimulate the imagination. Angry clouds, playful clouds looming large in the

Dutch sky, big, furry and full of character. I felt like I could reach out and pluck a tuft of cloud between my fingers. I could even pick out a storyline if I stared long and hard enough. I found it quite interesting to know that these beautiful Dutch clouds had names. They were named after the objects that they resembled, so if you saw a cloud that looked like an old man in a hat, it was probably the amiable grandfather cloud.

My friends noticed my budding romance with the Netherlands and were rather quick to caution me about the trials and tribulations that lay on the horizon.

"Don't get too comfortable," they said, "for the cold and wintry weather lies ahead. You need to get warm clothing, winter tires and a bunch of other expensive stuff."

I received with gratitude and some trepidation the tons of advice they provided on how to prepare myself for my first winter in the Netherlands. As expected of a newbie, I went all out to rise to their expectations.

Armed with a plethora of well-meaning advice and suggestions, I set about preparing for my first Dutch winter. One can never be too prepared for such things, especially with a thin subcutaneous layer.

I imagined myself frozen if I did not purchase each and every item on my warm clothing list. How could I not with the inhabitants of my household belting out the anthem of the movie Frozen at every turn? It did not help that I have a very active imagination and tend to play in my head the lyrics to every song I hear. I purchased gloves, shoes, boots, scarves, socks, winter tires, the works!

Then the countdown began.

The kids were excited at the possibility of a white Christmas.

Me? Not so much.

Each day they would wake up with the same question, "Is it snowing yet mum?" as they rushed to pull apart the window blinds.

Every night, they would predict that it would snow tomorrow.

It never did. We had two mini hailstorms, but no snow.

From my experiences so far, I can say that the climate in the Netherlands is not one of extremes. Thankfully, it lies somewhere in

the middle and as I always say, I would rather have a middle climate than one of extremes. During warmer times, it can get up to 22 degrees, which is warm but not too warm. It's not a sweltering kind of warm but rather, it's a "bring out your designer sunglasses and wrap a nice colourful scarf around your neck just in case" kind of warm.

When it rains, it doesn't pour. It drizzles. It's the kind of rain where you can just go about your business in spite of the showers. I like to call it non-disruptive rain. It doesn't drench, it teases for a short while and then stops as abruptly as it started, leaving you wondering what to do with the umbrella you carried out of the house in the morning.

My Dutch friends love to chat about the weather over coffee. You can often overhear them half-heartedly complain about the unpredictability of the weather. As is to be expected, due to the lack of snow during the recently passed winter, the weather has been quite a hot topic in these parts.

"Never have we had it so good" was a comment I have heard said repeatedly.

It is very nice and a welcome change to hear the Dutch comment on the weather so generously, as they have been known to be a tad critical on this topic. I do however get the feeling that they do this mostly to stimulate conversation and that they do not really hate the weather.

Just the other day at the beach, in the wind and the cold, as I shivered underneath my coat, cardigan and other warm paraphernalia, I saw a young man wearing nothing but a singlet on his back, voraciously consuming an ice cream! I shivered some more on his behalf and had to suppress the urge to run after him and offer a scarf.

As the month of April hurries by, the weather is nice and sunny and spring is in full bloom. My garden sprouts a new flower every day and the grass grows as fast as Rapunzel's hair.

There is NO chance of a snowy winter this year now.

Maybe I am the "Snow Taker". Maybe I brought with me the African sun, in which case I just might charge for it.

Whatever the case, I really must remember to retire my winter tires.

It's about time and I just might need them next winter.

Tamkara Adun moved to the Netherlands from Nigeria in 2013 with her husband and two children. She manages a blog at <u>Naija Expat in Holland</u>, where she shares her thoughts on expat life in The Netherlands as she juggles work, study and family in her new location. She is currently studying for her MBA at the Rotterdam School of Management, Erasmus University and is a contributing writer at <u>Women of HR</u>. You can connect with her on twitter <u>@tamkara</u>. Tamkara is an ardent lover of family trips, social media and great food. A few hours of blissful solitude as she digs into a great book is one of her favourite things. She looks forward to a day where trailing spouses no longer feel the need to trail but would rather blaze a trail.

XII

At Home At Last

Am I an expat?
Rosalind Van Aalen Grant
Tales From The Windmill Fields

Am I an expat? I do not know. Sometimes yes, sometimes no. I am British, but I quite often say that the only Britishness about me is my passport and my cups of tea with milk.

I left England when I was 10. We moved to Spain. I then left Spain, to come here to the Netherlands when I was 30. That is a long time in one country and not long in another.

I feel I am more Spanish than British. Did I feel like an expat in Spain? Only maybe the first few years, when we lived in the touristy area, frequented touristy bars and I went to an international school.

However, we then moved to a village in Valencia. I attended a Spanish school and everything changed. I was not an expat any more. I was a foreigner. In fact, our family was something special in the village, strange even! I loved it. I loved the attention, I loved being the new person, and I loved integrating. In Spain, I integrated because I had to.

After schooling, I set off to work and travel around France for three years and I did not feel like an expat. I experienced the feeling of being a working foreigner. We returned to Spain, (notice, I say "we", because by then I had picked up my Dutch husband along the way, at the Arc de Triomphe).

Was I an expat when I returned? I went out with other English friends, but we also had a huge number of foreign friends. Going down south (to the tourist area) was a special treat and something that, once we had been there for a while, we loved to leave. A friend who lived in the south had all expat friends. Was she an expat? Maybe.

Here, now in the Netherlands, am I an expat? I am living abroad voluntarily, although I probably would not have left Spain if I had had enough money to stay there and visit family often. The expat lifestyle here does exist and you can become involved with all kinds of expat gatherings.

Organising events and activities with other expat mothers is something

I enjoy because I like the idea of meeting people who are in the same boat, people who experience the same things as me. More importantly, these are people who speak the same language, people who can speak to my daughter in the same language as I do.

Sometimes, however, I am not an expat at all. I live in a very Dutch village and I have immersed myself in that world too. I sing in the choir. I have met a Dutch person with children the same age as mine, who could quite possibly be a new best friend. People say hello to me in the shops and recognise me.

It helps that I have learnt the language and that I am very outgoing. Nevertheless, it was hard when we first came here because we left a large group of friends behind. The Spanish are an extremely social people and their culture revolves around friendships. The more friends you meet every day, the wider your social outlook.

However, what I have found, and I know that many other expats here have too, is that the Dutch do not need any more friends. They have a few close friends, and that is enough. This makes it quite hard for somebody moving here.

My family is here to stay. We moved here for the long term. I would love to go back to Spain and, if you gave me enough money, I would probably consider it, but now, all the important things are here. I have a better career, a better house and we are closer to family.

I think the word expat has become very stereotypical. Many imagine an expat as somebody who lives abroad and stays in their own community, with their own nationality, someone who does not integrate and leads an entirely different life from the locals.

If I were only here for a short while, then maybe I would be a stereotypical expat and not integrate as much. However, that won't happen. It's just not me.

There are then many varieties, or species if you like, of expats, and everybody copes as an expat in their own way.

What would be my tips for future expats moving to the Netherlands?

Before you come, research expat groups in your area. Find out what activities they do and contact them before you arrive.

Once you arrive, go to your local *Gemeente* (town hall), which should have leaflets about activities in the area. My village has a cultural centre with many activities, including the choir I joined.

Go into the same shops every week in your village or town. Take time to say hello to people. One of the week's highlights is the market. All the stall owners know us now and it makes you feel like you're a part of something.

Get a good bike. Most Dutch have two bikes. One is a cheap bike they leave at train stations and one for home.

Last but not least, keep reminding yourself that it all takes time. Your new life will not all fall in place overnight.

Am I an expat? At times maybe I am, but quite often I am not. I am an international woman living and working in the Netherlands, who feels Spanish and has a British passport. Will I ever consider myself Dutch? No way!

Five years on, many things have got me thinking about how I feel about living here and in the Netherlands. I live on a Dutch street, in a Dutch village, my eldest daughter goes to a Dutch school and I have had a baby in the Netherlands. She goes to a Dutch child care provider, I sing in a Dutch choir, I work in a Dutch company, I ride my bike everywhere as if it was second nature, I complain about the weather and the trains.

Yes, I teach English, I speak English to my daughters, I still must have my tea, but even that has diminished into herbal teas. No coffee yet! We still celebrate Christmas and Reyes, we sing in Spanish, we, unlike the Dutch, are the impulsive, spontaneous people.

What has changed? I am beginning to feel like I belong, that I have found my feet. I am beginning to feel settled here. This is my new country. I even feel I have to defend it at times and miss it when I am away.

Online chats with other mums made me realise that I don't feel anymore those worries about other mums at the playground not speaking to me. I have become one of them, I suppose. They chat with me, not only at the playground, but in the supermarket too. I have had coffee with a few of them after my daughter had been round to play. Cycling with the baby on the front of the bicycle and my daughter alongside me is now not a

scary awful event, but part of everyday life.

I find myself not thinking about why is this so, but just go with it because it's the norm and I am now used to it. I still hate how everybody congratulates me, my husband, the kids, the dog and the next-door neighbour when it's my birthday, but I can live with that.

I am better at accepting the Dutch and their country. I think that is when you finally feel at home, when you accept the people and their culture. Acceptance is a big word and it can take many years to accept a foreign place as home, but the Netherlands are beginning to feel like home.

During a telephone conversation with a friend, I told her about these feelings and said I am stepping over to the dark side. It does not feel scary or wrong at all—in fact, it feels good.

Rosalind is the writer, expat and blogger behind the no longer existing blog Tales from Windmill Fields and Two Little Monkeys in Breda where she stroopwaffles about the Netherlands along with a cup of British tea and Spanish music. She has also been featured on many websites and publications including The Telegraph and ACCESS magazine. After moving to France with a backpack, she picked up her husband at the Arc de Triomphe and found herself 10 years later, moving to the Netherlands with a container full of stuff, a dog, a cat and a daughter. Now five years later she is still in the Netherlands, has had another child here, so has experienced and is experiencing everything Dutch child related, one of the reasons why she set up Breda Monkeys for families in the Brabant area.

Born to be Dutch

Zoe Lewis

George With Ears

I am my father's daughter. My dad has spent the better part of the last 45 years wandering from country to country, at first with the Navy and then as the mood took him. My mother stayed in the UK, while my father went off to far-off places like the United States, Saudi Arabia, Greece and finally Norway to find fortune (hah, not so much), adventure and a place where he fit.

Like my father, I left too. I gave it a good shot, but by 21, I'd figured out that England was not where I belonged. I packed up a few bags and went to Germany to visit my brother. I stayed for over a year and never looked back.

From Germany, it was Belgium, then Switzerland and finally landing in the Netherlands in 2001 at the ripe old age of 25.

It was like coming home. A whole country filled with people like me! The Dutch are often referred to as blunt, no-nonsense, straightforward— oh, and tall. Over the last 13 years or so of living here, I have seen a lot of people come and go (myself included) after struggling with the pragmatic Dutch and their plain-speaking ways. I've heard them referred to as rude and uncooperative and been utterly mystified by this. These were my people. After leaving in 2003 for a wee hiatus in France and Spain, I returned to the one place I fit.

Always the outspoken child, I grew up to be a stubborn and opinionated adult. Looking back at my gregarious childhood, I remember one particular time when my mother cringed in shame, looking desperately for a place to bolt as I asked "Mummy, why are that man's sideburns so enormous and ginger?" He was sitting across the table from us at my brother's school concert. "Zoe!" She reprimanded, making apologetic eyes at the good-humoured gent in question whilst trying to muzzle me. "Well, they are aren't they?"

Yup, that was me. Questions popped out of my mouth with as much surprise to me as the person being asked. Often referred to as a verbal bull in a china shop or a social hand grenade, I had no filter.

You see, though I am all the aforementioned adjectives, I am also British- a wee paradox, if you will. We Brits are trained to be the antithesis of all things straightforward. One simply does not ask a direct question and they never actually mean their reply. When asked, "How are you?" the pre-requisite reply is "Fine, thank you." They're not actually asking how you are, it's all about form. There are certain rules to be adhered to, rules that seem to have passed me by. You can almost guarantee that whatever a Brit says, they will mean the total opposite.

Perhaps having lived in a few other countries made my transition easier, or at least less of a shock, but even I (who, after years of training and self-discipline, had almost mastered the art of self-muzzling) have been caught off guard by the Dutch on occasion.

While speculating with a colleague as to the sexual orientation of a rather hot chap we worked with, she jumped off her chair and walked over to him. *"Ben jij een homo*?" (Are you gay?) she asked. I actually fell off my stool. She had done the unthinkable for all Brits. You never, ever ask someone this question to their face. The English part of me was screaming, "What the fuckity-fuck are you doing? Run."

Bloody hell fire! I stood there, caught like a deer in the headlights, not knowing if bolting, apologising or feigning ignorance was the best course of action, waiting for the guy to be indignant and tell us to do one. He smiled and said, "Oh no, but I get that question a lot." Jesus breakdancing Christ! I sat there stunned. Not only had she asked the question, but he had answered. Forthright and simple.

All around me, conversations turned into things I could enjoy. The metaphorical gag could come off. It doesn't stop there. It's not uncommon to be asked how much money you make or how much you paid for your house. There seemed almost no taboo questions. No more did I have to watch what I said, no more did I have to eat shit and smile. I could have an opinion, and say it out loud without fear of trampling all over delicate egos and feelings. I could be me.

Possibly the problem some people have is misinterpretation. Because the Dutch, on the whole, speak English so well, it is easy to forget that it's not their mother tongue. There is a difference between rude and blunt, a fine line if you will, and the Dutch seem to skate on it like the

Olympic champs that they are. I love it.

Maybe it's their relaxed attitude to swearing and sex that upsets people? In the UK, you have a thing called the watershed, which is a time of day, after 21:00, when television channels can broadcast programmes with adult content. Swearing and nudity are covered by the term adult content. One does not just drop the F-bomb during daylight hours, and you sure as shit do not see nipples in commercials.

The first time I heard fuck and shit on Dutch radio, I nearly crashed my car. I was so shocked, not so much at the profanity, (as let's face it, I swear a lot) but that it was two in the afternoon. I sat there stunned, thinking, "Wow, he can't say that." He did, and then went on to say it a few more times. These two words in particular have no power here. Sure, everyone knows what they mean, but if you really want to insult someone then you curse them with diseases.

I was on the tram one morning at stupid o'clock on my way to work, huddled into my jacket, reading my book and trying to find the will to live, when a teenager got on. All attitude and eyeliner, listening to her music, she swanned onto the tram and plonked herself in the seat behind me. The tram was virtually empty. Her music was so loud and obnoxious that the hairs on my neck stood on end.

I sighed, it was too damn early for this shit! I was not nearly caffeinated enough and in no mood. I turned around and asked her to either turn her music down or to sit in one of the 40 other available seats on the tram. The tirade that came out of her mouth was nothing short of spectacular. I was called (I'm paraphrasing here and the efficacy in English does not quite translate) "a typhoid, cholera, cancer whore."

Yes, if you want to make your point you swear in diseases. I sat there for a second trying to process this. It was a first. Not knowing if I wanted to stroke her sweet face for trying so hard or punch her, I settled for throwing back my head and laughing. I lost it. Clearly this was not the response she was looking for, so she tried again. Another freestyling tirade, with "cancer dog," more typhoid, and I'm fairly sure syphilis was thrown in there too with some random threats to my body and future children. It was adorable.

Not easily intimidated, I leaned over and with a smile on my face, I

quietly called her an amateur. If she didn't learn to keep her mouth shut, then at least learn to do it with style. "Run back home to mummy dear, you are playing with the big dogs." She got off at the next stop. It's true what they say, don't yell and shout—lean in, smile and threaten, it's scary as balls. Either that or my two cups of coffee and three-cigarette breath made her run.

Assholes are assholes wherever you go, whichever country you live in. The Dutch are the friendliest people I have ever met. They welcomed me and made me one of their own with no drama. Maybe it's because I don't fanny around with the niceties or hide behind double meanings. I know the difference between polite and rude, and for me being able to be direct is a godsend. Don't ask a question if you don't want the answer.

Zoe is an English woman married to a Dutch man with a lethargic Spanish greyhound and Machiavellian two-year old. She is a social hand grenade with two blogs, (because one just wasn't enough work) taking on life one grammatical error at a time. Find her at George with Ears or The Sleazy Bakeshop.

There's no place like home
Catina Tanner
Amsterdam Mama

It doesn't matter how many times I put on my ruby slippers, close my eyes and click my heels, I never wake up back home in my small southern town. Instead, I open my eyes, and I'm in Amsterdam, the Netherlands, the city that has been my home for the last 10 years.

It was all part of the almost-30 crisis. I gave up my corporate job, took out a student loan and moved to Amsterdam to start a new life as a graduate student. However, my plan was to return home, where days start with bacon, eggs cooked in fatback and a mini heart attack.

Making a life across the big pond wasn't as easy as I had imagined. First of all, I was back in school and learning another language. It's an entirely different language that includes pronouncing the letter "G" with a gurgle. The first time I spoke to a Dutchie and they hit the "G," I almost started performing the Heimlich manoeuvre on him. After the fourth "G" I realized they weren't choking on a piece of Gouda. Yet after six months of a scratchy throat, I mastered the Dutch language and was hacking up "Gs" like a native.

Once I could speak Dutch, I no longer had to shop by photo. My saving grace was that the supermarkets are the size of the produce section at a Walmart Superstore. Dutch supermarket aisles are lined with loaves of fresh bread and jars of weird concoctions to smear on their 10 daily slices. Dutchies will put anything on their bread, like 20 types of chocolate, cookies, butterscotch or cake sprinkles.

After filling your basket with bread and more bread, it's time for the checkout experience. First, you have to bring your own shopping bags and bag your own groceries. No experience in the pressure-filled corporate world could've prepared me for the stress of bagging groceries, simultaneously paying the cashier and resuming the bagging before the next customer's items mingle with mine. God, I miss bag boys!

Finally, you lug the bags to your bike, pray that it's not stolen and balance your groceries on your handlebars while cycling home. Yes,

these Dutchies do everything by bike. The Amsterdam streets are the size of sidewalks and you practically have to have a Saturday Night Smackdown to win a parking spot, so you learn to use your bike for most tasks. I even transported my six-foot Christmas tree home that way.

There are other differences, like greeting with three kisses, sitting in the birthday circle and the shameless nose picking, but the mother of all differences (pun intended) for me was the experience of becoming a mother.

In a country where soft drugs are legal, you have to beg, plead and end up signing away rights to your firstborn to get an epidural or any painkillers. After I was sawed in half giving birth to my first child via C-section, I was given acetaminophen for pain relief. My second child almost killed me after 36 hours of contractions and no epidural. My gynaecologist finally gave in after I threatened that if I didn't get an epidural, I would send my husband out for marijuana and mushrooms.

Once you have kids, you experience a whole new realm of cultural differences. Most moms work part-time, childcare costs three times what it does in the US and kids begin school at age four.

Also, having children means you have to celebrate Dutch holidays, like Sinterklaas. He arrives mid-November on a steamboat from Spain with his horse and hundreds of controversial little helpers, the Zwarte Piets.

I will never forget my first Sinterklaas experience watching this Gandalf-like man riding down the street on his white horse followed by hundreds of Zwarte Pieten, in their clown-like costumes, bushy afros and black painted faces. My instinct was to run for cover, but then I remembered I wasn't in the South anymore. Nevertheless, it's a tradition here, and these helpers put gifts in the children's shoes several nights a week until December 5th when Sinterklaas leaves a sack of gifts on the doorstep.

Finally, the most frustrating difference is healthcare. It's not only the gynaecologists who want you to suffer. After years of hearing, "You'll be fine, come back in a week" from my doctor, I learned how to manage the system. Its simple math. When explaining your illness, double the amount of time you've been sick, triple your symptoms and that equals help. But don't expect antibiotics unless your leg is about to fall off

from gangrene.

Actually, Dorothy had it right, there is no place like home. For now, I will keep on my wooden shoes, dream of bag boys at Super Walmart, and call Amsterdam home.

Catina Tanner was born and raised in the southern US but for the past 13 years has called Amsterdam her home. She is a communications professional for an international criminal court though her most treasured title is mom to her two half-Dutch children. She blogs about her experiences as an expat mother at <u>Amsterdam Mama</u>. You can also find an article or two on the web she has written in between bouts of sleep deprivation. Her two dreams in life are to become a writer, and to someday have children who sleep through the night.

XIII

Saying Goodbye

To bid farewell
Marianne Orchard
Like a sponge

If you live abroad, saying goodbye is part of life. You have the farewells when you first move away, the farewells each time you are back home there and return back home here and the farewells when someone from home comes to visit and leaves again. With these goodbyes, the one being left always says to the one leaving, "Phone me when you get there."

In Dutch you can use *afscheid nemen van iemand* to convey saying goodbye. *Afscheid* comes from the verb *afscheiden,* which means to separate. I like the idea of taking *afscheid* from someone. It has certain gravity to it, like a man in a tailcoat bowing as he takes his *afscheid.* This is because it sounds like the English "take leave of someone", which is slightly too Jane Austen for everyday life. To a Dutch person, however, *afscheid nemen* is a perfectly normal way of saying goodbye and has nothing of the milady about it.

The Dutch dictionary says *afscheid nemen* is het *vaarwel zeggen.* This had me thinking (because I'm really clever) that the English farewell and the Dutch *vaarwel* must be related, and that *vaarwel* must come from *varen* and *wel* and would therefore have originally meant have a safe journey. I assumed the same must be true for the English farewell. My dictionary of etymology confirmed my suspicion and told me that farewell probably came from *faren wel,* which is travel well or have a safe journey.

I moved on to the word *fare* and discovered it was rich in meaning. First, there was the noun meaning the cost of conveyance and food provided or eaten. This probably comes from the Old English words *faer* and *faru* (from the verb *faran*), which both mean journey. Then there was the verb *fare,* which means to get along or to eat food and which also comes from the word *faren.*

I had always thought that *farewell* came from the verb meaning to get along, thus meaning something like "hope you do well." The idea of farewell meaning, "have a safe journey" added a new dimension to it for

me.

A while back we said farewell to, or took *afscheid* of, my mum, who had been visiting. She phoned in the evening to say she'd arrived home safely. In the same week we also took *afscheid* of my father-in-law at his funeral.

This is where it became clear that small children have no sense of what death means, because for my daughter, who was five at the time, both events were the same. Granny was there and then she wasn't; Opa was there and then he wasn't. She didn't realise that the difference was that Opa wouldn't be phoning to say he'd arrived safely.

Marianne Orchard left Britain an eternity ago to study in Germany. She met her Dutch husband there, and moved with him to the Netherlands. They now live with their two children in a village in Friesland. Marianne works as a Dutch-English translator, and writes about the Dutch and English languages on her blog Like a Sponge.

Comfortable with the uncomfortable

Kerry Dankers

Foodlovas

"What will you miss most?" says every human that I have encountered in the past few weeks. It was the same story four years ago when we decided to move away from our home country of Canada to live a life of adventure in the Netherlands. That was what we were calling it: our adventure. My husband and I had found ourselves in the unique situation of having absolutely nothing tying us down at the ages of 29 and 28, respectively. We had both just retired from athletic careers and finished our studies. My husband wanted to do his PhD and I was ready to pop some kids out.

We decided to move to another country and ended up in the Netherlands. It was relatively well thought out. My husband has family from there, he spoke the language and we had been there dozens of times to compete in our sport. Yes, we knew that it rained. Our families were dismayed and our parents were crushed that we would be starting our family abroad, but, regardless, we were sent off with tons of love and support.

The first year was hard. I was newly pregnant, spent hours and hours home alone and had massive homesickness for the food I left behind. I couldn't find anything that I wanted. I couldn't get a job because I was pregnant. About a month in, I decided it was time to stick my neck out. Out of character for me, I showed up at a handicraft group put on by an organization associated with the university my husband was attending. I made my first friend that day: a 42 year-old Brazilian woman. She was my saviour. Besides being an awesome friend and a super sweet person, this woman taught me to open up and reach out to people around me. While I cowered in the corner of the elevator trying not to make eye contact with others, my friend knew everyone in the building. It was time for a change. It was time to become comfortable with the uncomfortable.

The next three years were some of the best of my life. With my new motto, I became more daring, more open, more willing to put myself out

there. I joined groups, made coffee dates and playdates but also became a hell of a lot more comfortable just being alone and self-sufficient. Sure, I had my husband, but I had a lot of hours to fill while he was at work. I morphed into a new person. Still the same old me, but more confident and less shy.

Now when I think about going back home, it scares me a little. I have really changed. What will it be like to live among Canadians again? I read a fabulous little analogy recently and I am going to share it with you. Picture yourself in your home country. You are a circle and everyone around you is a circle too. You move away to a new country and now you are a circle among squares. You definitely don't fit in. Through the years you start to change and get some points and you become a triangle. You will never be a square, but you have changed. Upon returning home, you finally find yourself as a triangle among circles, a little too pointy.

I find this analogy amazingly accurate. I think about it a lot. It's funny, because when I moved to the Netherlands I was truly like a circle: smooth, polite, soft. The Dutch were definitely like squares: elbows-out assertive, blunt-edged and tough. I like to think that I took the good points from the Dutch and shed the bad Canadian attributes when becoming my triangle. I must admit that going home to Canada might not be as bad as other countries could be. In reality, Canada is very diverse and I'm almost certain I won't be the only triangle be-bopping around. I am thankful for that.

With all my pointiness intact, I return home in one month. My days are filled with normal everyday stuff accompanied with panicky thoughts about moving. Selling, giving away, throwing out, packing, money, sadness, joy are all the things that are fighting for space in my brain.

What I will miss most are my friends that have truly become my family. I will miss biking and being active without even trying. I will miss the honest nature of the Dutch people and lifestyle. I will miss *muisjes*, which clearly contain crack and my addiction may only be cured by moving across a large body of water. I might even miss the weather.

What I want to say to the lovely people who ask me this tough question is "A better question to ask is, what have I learned from this

experience?" Then you will see the new me: the person I have become because of this awesome adventure and by becoming comfortable with the uncomfortable.

Kerry Dankers is an ex-Olympian Canadian speed skater who up and left her own country to live a Dutch adventure. Two kids, a new language and her husband's PhD later, her time is up and she is returning to the homeland. Four years of going Dutch has left her a more assertive, cheese-loving, penny pincher, but she will never travel without brown sugar again. Although Dutch food has been the demise of her food blog at <u>*Foodlovas*</u>*, you can still find her cruising on her bike with two kids strapped on, sans helmet, living the Dutch dream in Canada.*

The story of saying goodbye
Lynn Morrison
Nomad Mom Diary

One of the best and worst parts of being an expat is having to say goodbye. We enter each phase in our traveling lives with one hand waving to those behind us, and the other beckoning to the adventures up ahead. We say goodbye often not knowing when or maybe even if we'll ever be back.

It was with heavy hearts and souls straining with excitement that my family and I said goodbye to the Netherlands nearly one year ago. During our four-year stay, we had built up a life that we could truly call our own. Our own house. Our own jobs. Our own little family. Our own friends. It had taken so much hard work and attention to create the existence we were going to have to leave behind.

Although it was our own hands tearing down the edifices of our Dutch lives, it pained us nonetheless.

In those final hours, we could not find any fault with our Dutch adventure. The tree-lined canals, the cobbled bike paths, the way the old so effortlessly romanced the new. Our final walks through Delft were lost in deep reflections and sad adieus. We waxed poetic about all of the things we were going to miss once we were gone. How would we ever find a place half as fantastic as Delft?

We fell asleep on that final night, hearts heavy, deep in the embrace of the ferry to the U.K., literally following the path in our dreams. We awoke to the dawn of a new day, a new country and a new life.

In those first few weeks after the move, we slipped off our Dutch memories like a second skin and jumped headfirst into the new. "Look at all of these parks," I exclaimed. "And they're always open," responded my husband. "We can go anytime we want," cheered the kids.

Our garden is thrice as big. We have a driveway and a garage. Stores are open on Sundays! There is so much more to see and do! How did we survive for so long without all of this? We were overjoyed and our enthusiasm blinded us to any faults.

I learned that you cannot truly look back with any clarity until you have worked your way past the initial separation pain. You have to wait until some of the shininess has worn off of the new. You have to wait until you have rediscovered some semblance of normalcy. For some that might be only a few weeks; for us it was eight months.

I tell you all of this to explain why it has fallen to me to write the story of saying goodbye. I want you to understand that I write these thoughts with a clear head and a steady heart. I won't try and flatter you with platitudes. I won't sling mud. I will only give you the unvarnished truth of how living in the Netherlands changed my life.

The Netherlands made me into a dreamer. Somewhere in the midst of the *kopjes koffie*, the *boterhamen* and the oh-so-straight in your face talk, I discovered my imagination. Perhaps it was the black and white existence of the Dutch that made me seek out the greys in my own life. Perhaps it was simply the separation from everything that made me who I was. Likely I'll never know. The one thing I do know is that the incredibly supportive system, the *toeslagen*, the flexible work hours, never having to guess where I stood with my clients, all of this left me the freedom to plumb the depths of my mind and uncover thoughts and desires I never knew I had. For 31 years of my life I followed paths trod by others. It took moving to the Netherlands to put me on a path of my own.

The Netherlands made me into a fighter. I've never been a shrinking violet, but I've equally not been someone to go and stand on desks to get what I want. My years in the Netherlands taught me to be my own advocate. If someone in authority said something that was clearly wrong, no one else was going to step up and correct them on my behalf. I had to be prepared to argue with the nurse at the *consultatiebureau* who thought my child needed less vegetables and more bread. I had to "clarify" things with the careless rental agency, convince my clients that there might be another, perhaps even better way of doing things. I had to educate myself and find the confidence to believe that sometimes I did know best. Then I had to find the courage to say it out loud... again and again and again.

Perhaps most importantly, living in the Netherlands taught me never to assume that there is one "right" way. When you create a new life

in a new country, it is inevitable that you will have to do some of that creation using the local techniques. Some days this can seem like a mountain that dwarfs Everest, but other days it is the opportunity to discover a brand new way to do a mundane task—like biking, which I hadn't done since I was a child. Commuting on two wheels brought back flashbacks of endless summer afternoons spent wheeling around the neighbourhood.

And the tiny houses. Did I really need all of the stuff I'd accumulated over the years? Suddenly the American dream of more and bigger is better seemed like a silly and wasteful passion. I stopped buying five almost-right shirts and threw myself into finding one great one. I doubled the size of my garden by opening the back gate and traipsing a path over to the neighbours. While my parents back home were complaining that their neighbours were infringing on their half-acre of land, I was revelling in my newfound ability to yell over the back gate to say hello to mine.

The "off the shelf" life in the Netherlands wasn't perfect, not by a long shot. Living abroad then and now again has made me realize that the "off the shelf" life anywhere isn't perfect. You need to mould yourself and your surroundings like a giant ball of dough. You start with a few basic ingredients. You dash in some spices, some familiar and some unfamiliar. You mix it all together and then set it aside to let it rise to the occasion. You let time work its magic, checking in from time to time to make sure that nothing has gone awry. One day, you peek beneath under the covers and see that you've created this perfect ball of dough out of your sweat and tears, your thoughts and fears, the new adventures and the glue of newfound friendship holding it all together.

I carried my beautiful ball of dough with me to the UK. I dusted it with flour and put it into the oven and let it bake for eight long months. Now it is done, we pull it out of the oven, slice it open and let the steam of memories wash over us. All of our adventures lie sliced on a plate in front of us, there to be put together into *boterhamen* or enjoy alone with a smear of *roomboter* on the top. They will nourish our hearts and minds for years and years to come.

Lynn Morrison is a smart-ass American raising two prim princesses with her obnoxiously skinny Italian husband in Oxford, England. As the Nomad Mom, Lynn exposes the truth about what it's like to be married to an uber-brainiac and the mother to multilingual children. The truth is, her days are pretty much like everyone else's, just with more pronunciations of the word "water". Lynn likes nothing better than to curl up with her MacBook and a glass of wine and write thought-provoking essays on why sweatpants are the new black or why it is impossible to suck it in for eight hours. If you've ever hidden pizza boxes at the bottom of the trash or worn maternity pants when not pregnant, chances are you'll like the Nomad Mom Diary. You can also find Lynn over on BLUNTmoms, Scary Mommy, Mamapedia, Bonbon Break and on the Huffington Post.

Participating Blogs

The European Mama - Olga Mecking

The Nomad Mom Diary - Lynn Morrison

Stuff Dutch People Like - Colleen Geske

Finding Dutchland - Rina Mae Acosta

The Three Under - Farrah Ritter

Neamhspleachas - Molly Quell

Currystrumpet - Deepa Paul

George With Ears - Zoe Lewis

Dutch Australian - Reneé Veldman-Tentori

Expat Life With A Double Buggy - Amanda van Mulligen

MissNeriss - Nerissa Muijs

2 Little Monkeys in Breda - Rosalind Van Aalen

Olympic Wanderings - Caitlyn O'Dowd

Smart Tinker - Lana Kristine Jelenjev

Expat Since Birth - Ute Limacher-Riebold

Life In Dutch - Aislinn Callahan-Brand

The Non-Hip Hippies - Alexia Martha Symvoulidou

Naturally Global - Katherine Strous

Amayzmom - Shivangi Tiwari

Naija Expat In Holland - Tamkara Adun

Amber Rahim - Amber Rahim

Amsterdam Mama - Catina Tanner

Like A Sponge - Marianne Orchard

The Tini Times - Damini Purkayastha

Bardsleyland - Donna Stovall Bardsley

Foodlovas - Kerry Dankers

Social Fusion Amsterdam - Iulia Modi Agterhuis

Acknowledgments

Writing this book has not only been fun, but also extremely educational. We have learned a lot in the process, and we certainly wouldn't have been able to finish this book if it hadn't been for all the help and support we got. Writing a book is so much more than writing. It's cooperation.

We therefore would like to thank to following people who generously donated their expertise:

Our fabulous illustrators, Zoe Lewis and Damien van der Velde.

Our eagle-eyed editors, Molly Quell and Deepa Paul Plazo.

Ewa Bartnik (Olga Mecking's mother) for helping with edits and Witek Bartnik (Olga Mecking's brother) for formatting the whole thing. Damini Purkayastha and Molly Quell for taking on the arduous task of preparing the book for print.

Lynn Morrison for coming up with the idea for this book in the first place and getting the process started.

Olga Mecking, we thank you from the bottom of our collective hearts. She set deadlines and forced us to meet them, kept the entire process on track and without her efforts we would not be here today.

Last but not least, we thank all of our writers, who helped turn our vision into reality by sharing their stories, cheering one another on and generally just being the fabulous writers that they are.

Thank you!

Printed in the USA
CPSIA information can be obtained
at www.ICGtesting.com
LVHW010720100624
782803LV00007B/585